Japan 1945

A U.S. Marine's
Photographs from
Ground Zero

Japan 1945

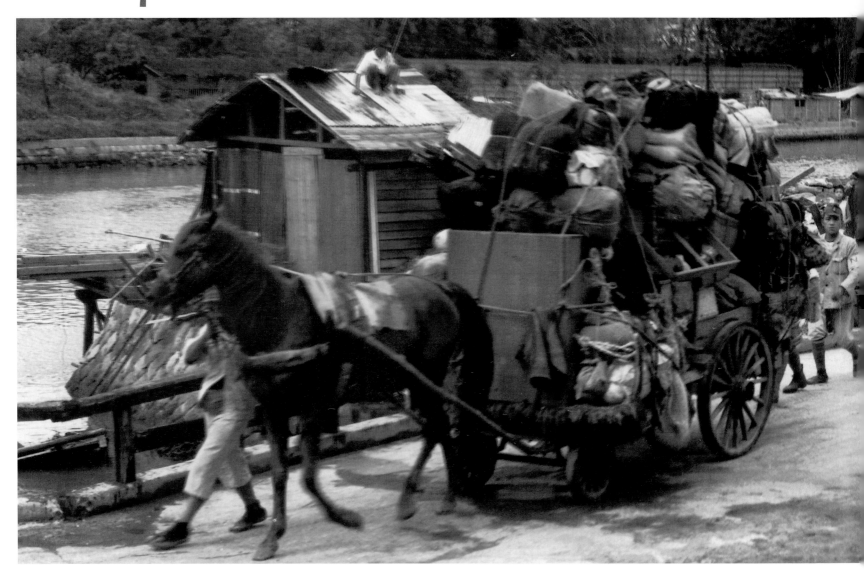

A U.S. Marine's Photographs from Ground Zero

Joe O'Donnell

Vanderbilt University Press ▪ Nashville

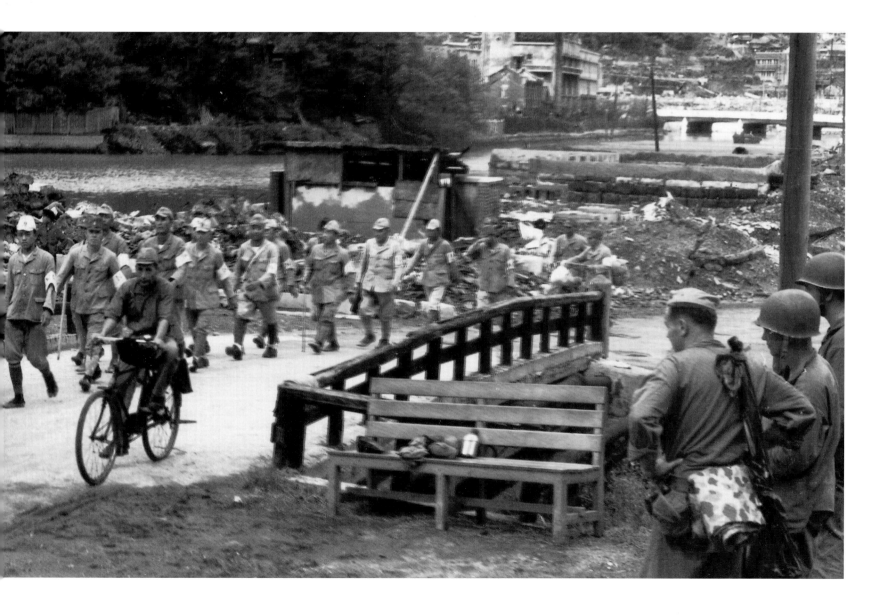

© 2005 Vanderbilt University Press

All rights reserved

Foreword © Mark Selden

First Edition 2005

Second Printing 2005

This book is printed on acid-free paper.

Manufactured in the U.S.A.

Design by Gary Gore

LIBRARY OF CONGRESS CATALOGING-IN-PUBLICATION DATA

O'Donnell, Joe, 1922–

 Japan 1945 : a U.S. Marine's photographs from Ground Zero / Joe O'Donnell; foreword by Mark Seldon.—1st ed.

 p. cm.

ISBN 0-8265-1467-7 (cloth : alk. paper)

 1. War photography—United States—History—20th century. 2. World War, 1939-1945—Japanese Americans—Pictorial works. 3. Bombing, Aerial—Japan—Pictorial works. 4. World War, 1939-1945—Aerial operations, American—Pictorial works. I. Title.

 TR820.6.036 2005

 779.'99405352—dc22

 2004017367

Contents

Foreword
After the Bomb: Hiroshima, Nagasaki, and the Photographic Record

Mark Selden

In the wake of Japan's surrender, the U.S. military set out to document the damage inflicted from the air on the Japanese homeland. Firebombing had destroyed central areas of 64 Japanese cities, killed hundreds of thousands of civilians, and left thirteen million homeless in the final months of the Pacific War. The atomic bombing of Hiroshima would take another 140,000 lives, and that of Nagasaki an additional 70,000 by the end of 1945, leaving many more to suffer lifelong effects of blast, fire, and radiation.

On September 2, 1945, 23-year old Marine Sergeant Joe O'Donnell filmed the American landing near Sasebo. His panorama reveals a formidable U.S. naval armada in a pristine coastal area off Kyushu with paddy fields etched into the hills and rolling mountains as far as the eye can see. Over the next seven months he would travel by plane, jeep, and horseback across Western Japan, chronicling the devastation wrought by the American air campaign in Sasebo, Fukuoka, Hiroshima, and Nagasaki. His photographs, of course, reveal the obliteration of Japanese cities. More important, some of the most poignant images in this collection illuminate the plight of bomb victims including the wounded, the dead, the orphaned and homeless.

The Photographic Record of the Atomic Bombing

Pictures of Hiroshima and Nagasaki have seared the consciousness of people throughout the world. But what images have circulated widely, and what images have been censored or suppressed? When the plutonium bomb exploded over Nagasaki, within one-millionth of a second the temperature rose to several million degrees centigrade, giving rise to a fireball and mushroom cloud whose image was circulated throughout the world in a U.S. Army Air Force photograph shot minutes after the explosion. Who has not been transfixed by the mushroom cloud, the visual counterpart to President Harry Truman's official proclamation announcing the bomb to the world on August 6, 1945: "It is an atomic bomb. The force from which the sun draws its power has been loosed against those who brought war to the Far East." The mushroom cloud, rising above Hiroshima or Nagasaki, elides the city below and its inhabitants. This iconic representation of U.S. supremacy at the moment of nuclear monopoly provides no visual reference to the dead, the wounded, or the irradiated. Yet no viewer of that image can be entirely oblivious to the fate of its invisible victims.

A second signature official photograph circulated by U.S. authorities pans the ruins of Hiroshima. The gutted frames of a few buildings is all that remains visible on a site where a city of 350,000 people had stood. Again interdicted from the picture are the dead and mutilated.

Six decades after Hiroshima and Nagasaki, the most compelling photographic images detailing the human consequences of the bombing of Japanese cities remained hidden from American view. Joe O'Donnell's photographs provide the first sustained American gaze on the destruction inflicted by the bombing of these cities, represented here by Sasebo, Hiroshima, and Nagasaki. They document the toll that firebombing exacted on the built environment: Sasebo in September 1945 is a city in ruins, inviting the viewer to reflect on the striking resemblance to the atomic landscapes of Hiroshima and Nagasaki. However, while there is an abundance of detailed data on the numbers and conditions of the atomic dead and wounded, we know nothing of the numbers who died in Sasebo and scores of other bombed cities. The significant exception is Tokyo where a single devastating raid is said to have taken 100,000 lives, left more than one million homeless, and destroyed much of the inner city.

The U.S. aerial bombardment of Japan, building on techniques honed in the 1944 British–U.S. bombardment of Dresden and Munich, would shape subsequent wars. The direct attack on civilian populations through strategic bombing, so strongly condemned by President Franklin Roosevelt in his 1937 warning to the Nazis,

would subsequently become the signature and centerpiece of American warfare. It was an approach that other air powers would emulate, though none would rival the U.S. in the toll inflicted on civilians in air campaigns.

O'Donnell, in his most memorable work, takes us to the center of the human toll of the bombing. Photographing a 14-year-old Nagasaki burn victim (page 70), he recalls that "flies and maggots feasted on his oozing sores. I waved the flies away with a handkerchief, then carefully brushed out the maggots, careful not to touch the boy's skin with my hand. The smell made me sick and my heart ached. . . ." At that moment, literally brushing away the human horror inflicted on a single youth, O'Donnell resolved that "I would not take other pictures of burned victims unless ordered to do so." Although we encounter one other image of a severely burned "Victim with Rope" (69), a man whose multiple layers of rags hid his burned, rotting flesh, *Japan 1945* exemplifies what John Dower has called the photographer's averted gaze. The decision to turn away from the most horrific images of inhumanity—notably the maiming and killing of women, children, and the elderly—is here made explicit by the photographer. Gazing into the horrors that nuclear war inflicted on civilians, O'Donnell averted his gaze. While recording the destruction of the cities, he is as good as his word to go no further in documenting the human wreckage wrought by nuclear or incendiary bombing.

The Japanese Photographic Record of the Atomic Bombing

Japanese photographers shot from inside the inferno that was Hiroshima and Nagasaki, arriving within hours, or in some cases days, of the holocaust. Their photographs convey, as no others could, the horror of the destruction that the bomb visited on human beings, nature, and the built environment: in closeups of mangled and burned corpses of children, in hospital wards over-flowing with the dead and wounded, in the patterns of a summer kimono burned into the back of a victim, in dazed people fleeing the flames, sometimes walking, sometimes crawling or being carried, in detailed records of wounds inflicted by blast, heat, and radiation, and in the shadow of a human figure burnt into a stone façade, to name a few.

Nagasaki Journey: The Photographs of Yosuke Yamahata, August 10, 1945 is the work of atomic photography that is most accessible for American readers. With smoke rising across the city, Yamahata, a Japanese army battle photographer, presents a landscape of death, destruction, and disorientation. Few visual records so compellingly portray the shock and awe of war. However, as Abé Mark Nornes observes,

> [Yamahata's photographs] look as though he was unsure how to go about photographing the battlefield of atomic warfare. The horizon is often tilted, as if the whole world is askew. Many of the photographs seem to be about nothing in particular or about rubble. The occasional snapshot shows the inexplicable: a scrap of something hanging high in a tree, a dead horse underneath a carriage, a body burned beyond recognition. The people in the photographs . . . inhabit the edges of the frame, looking out to spaces beyond the camera's viewfinder. . . . Nagasaki is gone. The composition of the photos always seems to miss its mark, as though Yamahata had no idea how to frame his experience.[1]

Perhaps the phenomenon described by Nornes is another version of the photographer's averted gaze, or what the psychologist Robert Lifton has termed psychic numbing in the face of the enormity of the destruction. For this viewer, that disorientation heightens the emotive power of the Yamahata images and those of other photographers operating in the immediate aftermath of the bomb. They detail, as no later photographs could, the magnitude and

character of the destruction and disorientation, capturing the faces and bodies of its victims, many of them infants and children.

Joe O'Donnell and the American Photographic Record

By the time that O'Donnell arrived in Japan, three weeks after the atomic bombings, the dead had been cremated and the cleanup of cities begun. To be sure, orphaned children and the homeless still roamed the streets, but the most severely injured had been moved to hospitals or were cared for at home. Traces of the dead were nevertheless present everywhere in the sights, sounds, and smells. And in O'Donnell's images. Climbing to the top of the ruins of a Sasebo building, he found that "the high-rises had acted like huge ovens that roasted the trapped people . . . the stench of the smoke-blackened bodies . . . filled the stairways and halls" (page 13). In Nagasaki "the extraordinary temperatures caused brains to boil and skulls to explode" (page 78). What lingered was the "feeling of stench, or smell. The look of a place that is barren. Nothing moving. No birds, no dogs, cats, nothing."[2]

Three young women in kimono cover their noses and mouths with scarves to block the smell of burning flesh from a nearby crematorium (page 24). Three skulls and scattered bones remain in a field surrounded by scattered sake bottles left to console the spirits of the dead (page 70). One poignant image is of a pre-teenage boy, his young brother on his back. "I was photographing cremation sites, and I was on a little hill looking down at the water. They had a pit dug, and they were burning human bones and people. I turned and looked down and saw this little boy. . . . I didn't know why he was bringing his brother. I had no idea he was dead, and all at once, the men came up to him. They had white masks on and they took the little boy off. The boy stood there at attention and watched them lay his brother on the coals, and that boy never moved" (page 74).[3]

Some of the most memorable photographs are of a cross-section of the surviving victims of the bombings. Particularly poignant are the children: a young girl in kimono who had lost all hearing after a bomb exploded nearby (page 72); a barefoot boy of perhaps six wheeling a makeshift cart carrying two young boys through the rubble of Nagasaki (page 71).

While the thousands of photographs O'Donnell took in his official capacity as a Marine photographer disappeared into military archives, he was able to circumvent the censors and bring out three hundred images shot with his personal camera. These are the basis for the present volume.

The bombing of Japan left indelible impressions on O'Donnell. "The people I met, the suffering and struggles I witnessed, and the scenes of incredible devastation . . . caused me to question every belief previously held about my so-called enemies."[4] Locking the negatives in a trunk on his return to the United States in spring 1946, he resolved never to open it. The memories "were so devastating—the faces of people with no ears, no eyebrows, no hairs, no lips—it was pretty hard to look at, and it was just that I, personally, didn't want to go through it again . . . And so I locked that trunk . . . and it stayed locked for 45 years."[5]

Censorship and the Photographic Record of the Atomic Bomb

The history of the photography of the atomic bomb, no less than of documentary and fictional writing, is one of official censorship. The United States suppressed the most powerful images of the impact of the bomb on Japanese cities and people. Throughout the occupation years it denied the world, and particularly the Japanese people, access to photographic images of Hiroshima and Nagasaki. Concurrently, it monopolized and restricted scientific evidence about the effects of the bomb. In Japan, on August 6, 1952, a

special issue of *Asahi Graph* opened the floodgates to atomic photographic and graphic arts. Books and magazines were published and exhibits staged. Eventually, survivors' paintings and drawings were collected, exhibited, and made into books and documentaries. Yet to this day, many of the most powerful images of the destructiveness of the atomic bombs, have rarely been seen outside Japan.

The United States introduced comprehensive military censorship of photographic and other war images during World War II and has practiced it ever since. Notably elided from view are the dead and maimed bodies of soldiers and civilians. Documenting war without what Susan Sontag has called the "deflating realism" of its photographed agonies culminated nearly six decades later in the introduction of embedded reporters and photographers in the Iraq War of 2003. O'Donnell's photographs were to have been included in the Smithsonian's planned *Enola Gay* exhibit in 1995, the fiftieth anniversary of the Hiroshima and Nagasaki bombings. When super patriots faulted the museum for insufficient triumphalism, the entire exhibit was scrapped. Visitors were left to view the aircraft that dropped the atomic bomb on Hiroshima with a spare account of the events that elided all mention of the toll in human lives or the half-century debate over the decision to drop the bomb. The publication of Joe O'Donnell's photographs is one important milestone in coming to grips with atomic bombing and the place of the United States in defining the nuclear age.

Other Photographic Resources

- Many photographs by official U.S. sources and by Japanese photographers can be seen in *Hiroshima and Nagasaki: The Physical, Medical, and Social Effects of the Atomic Bombings* (New York: Basic Books, 1981) by the Committee for the Compilation of Materials on Damage Caused by the Atomic Bombs in Hiroshima and Nagasaki.

- *Nagasaki Journey: The Photographs of Yosuke Yamahata, August 10, 1945* (San Francisco: Pomegranate Books, 1995) edited by Rupert Jenkins, is the most readily available English-language introduction to Japanese atomic photography.

- The fullest graphic record of the atomic bombings is in the six-volume Japanese work by Nihon Tosho Sentaa (Japan Book Center), *Hiroshima Nagasaki Genbaku Shashi Eiga Shûsei [Hiroshima and Nagasaki: The Atomic Bombings as Seen Through Photographs and Artwork]* (Tokyo: 1993).

- *Document 1961: Hiroshima–Nagasaki* (Tokyo: The Japan Council Against Atomic and Hydrogen Bombs, 1961) brings the camera up close to produce the most memorable and haunting visual examination of the human consequences of the atomic bombing.

- The other classic visual imaging of the atomic bomb is Maruki Iri and Maruki Toshi, *Genbaku no zu [The Atomic Murals]* (Tokyo: Kodansha, 1980) and the accompanying video recording of the work, "Hellfire: A Journey from Hiroshima" produced by John Junkerman and John W. Dower (First Run/Icarus Films, 1986) which introduces the memorable atomic murals painted by the Marukis.

- Japan Broadcasting Corporation (NHK), *Unforgettable Fire: Pictures Drawn by Atomic Bomb Survivors* (New York: Pantheon, 1977) is the best collection available in English of survivor drawings and paintings.

- The film by Erik Barnouw and Paul Ronder, *Hiroshima–Nagasaki, August 1945*, was made using footage shot by the Nichiei Japanese team in the weeks following the atomic bombings and confiscated by U.S. authorities, not to be returned until 1967.

- A celebratory volume is Donald M. Goldstein, Katherine V. Dillon, and J. Michael Wenger, *Rain of Ruin: A Photographic History of Hiroshima and Nagasaki* (Dulles, VA: Brassey's, 1995), which

provides the fullest access to the official military record and documents the destruction of the two cities while largely eliding the human consequences of the bomb.

- The Hiroshima Peace Museum and the Nagasaki Atomic Bomb Museum present print and graphics materials at *www. pcf.city.hiroshima.jp/peacecite* and *www1.city.nagasaki.nagasaki. jp/abm/abm_e/index.html* from which the most powerful images have been eliminated in one of the most poignant examples of the averted gaze.

Notes

I am indebted to John Dower and Herbert Bix for critical comments on an earlier draft of this foreword.

1. *Japanese Documentary Film: The Meiji Era through Hiroshima* (Minneapolis: University of Minnesota Press, 2003), p. 191.
2. Joe O'Donnell, interviewed by Noah Adams, *All Things Considered*, NPR, June 28, 1995.
3. Ibid.
4. From Preface of this book, page xiii.
5. Joe O'Donnell interview, *All Things Considered*.

Preface

My story begins in 1941 when I enlisted in the U.S. Marine Corps. A nineteen-year-old high school graduate full of anger towards the Japanese, I wanted to get to the South Pacific. However, the Marine Corps had other plans, and I soon found out that, instead of a rifle, the only thing I would aim at the Japanese would be a camera.

Four years later while en route to Japan with the invasion forces, I heard about the atomic bombs. With everyone else on board ship, I celebrated the war's end, little knowing that for me it was just beginning.

As a U.S. Marine Corps photographer, I waded ashore at Sasebo on September 2, 1945. I was a twenty-three-year-old sergeant, and my orders were to document the aftermath of U.S. bombing raids in various Japanese cities.

For seven months I toured the mainland of Japan, from Sasebo to Fukuoka, to Kobe, from Nagasaki to Hiroshima, the war inside myself growing. The people I met, the suffering I witnessed, and the scenes of incredible devastation taken by my camera caused me to question every belief I had previously held about my so-called enemies. I left Japan with the nightmare images etched on my negatives and in my heart.

Upon my honorable discharge in March 1946, I placed the three hundred negatives in a trunk and closed the lid, never intending to open it again. I wanted to forget and go on with my life.

But that kind of grief cannot just go away. After twenty years as a White House photographer, I retired with a medical disability later discovered to be caused by my radiation exposure. While numerous surgeries and treatments helped to ease my physical suffering (which can't be compared to the sufferings of those unfortunate people who survived the bomb), I remained obsessed by what I had seen.

On a religious retreat to the Sisters of Loretto Motherhouse in Kentucky, I saw a sculpture that had been done by a resident nun, Sister Jeanne Deuber. The sculpture, a life-sized figure of a flame-scarred man on a cross, was titled "Once." It was created in memory of the victims of the nuclear attack on Hiroshima and Nagasaki by the United States. When I looked at the photographs of atomic bomb victims imprinted on the Christ-like figure's body, I felt everything from inconsolable grief to violent outrage. So much horror, so much waste, so much inhumanity to innocent people, many of them women, children, and the elderly! It was a terrible emotional ordeal for me to relive the past, but in the end I was inspired.

I purchased the sculpture, went home, and opened the trunk. Miraculously, the negatives had survived cold, wet basements and

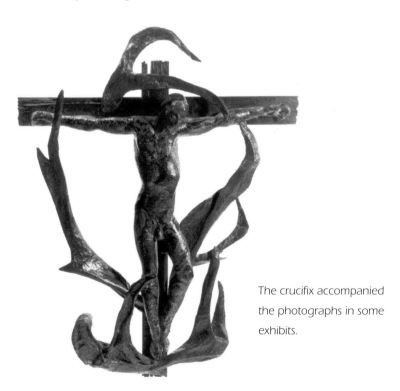

The crucifix accompanied the photographs in some exhibits.

hot, humid attics; they were in excellent condition despite the passage of nearly half a century.

As I took them out, half afraid to look at them, the frightful images turned into real life scenes from my memory. I could see the victims with maggots covering their bodies, hear their cries for help, smell their burned flesh; and I could remember three children sharing an apple dense with black flies. I became depressed and dreaded going to sleep because the repulsive nightmares kept taking me back.

Finally I realized I could no longer run away from my feelings. In 1988 I met a young woman, Jennifer Alldredge, who was writing children's stories and raising a family. The following year we spent hours looking at the photographs, and she would ask questions to get me to remember. That collaboration resulted in a book published in Japan in 1995 by Shogakukan. This new edition from Vanderbilt University Press adds almost twenty photographs.

I would like to thank my wife Kimiko and my friend Furman York for their assistance in gathering the materials for this edition.

—Joe O'Donnell

Landing

Mass

Early morning the day before we landed a special mass was held. Despite the early hour, the heat was incredible.

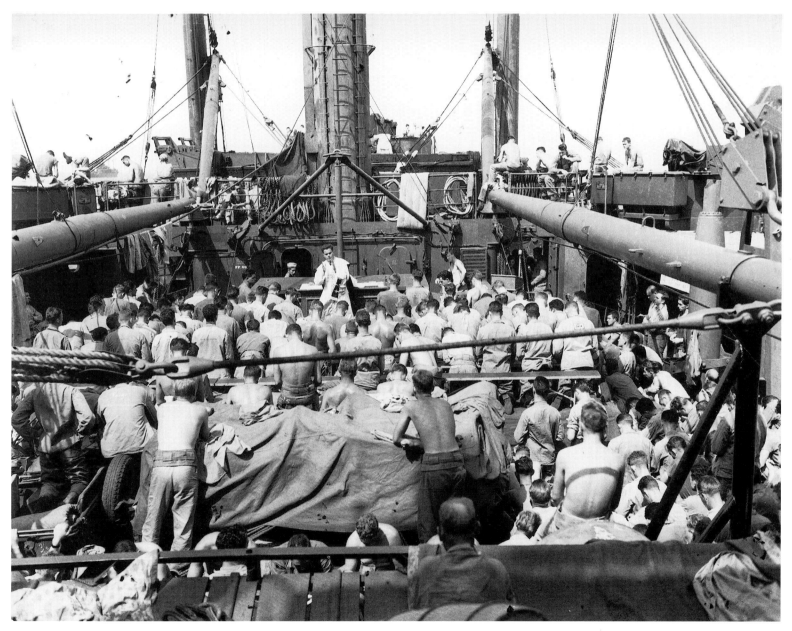

Sacrament

Catholics and Protestants joined together in thanks that we were now Occupation troops, not invasion forces.

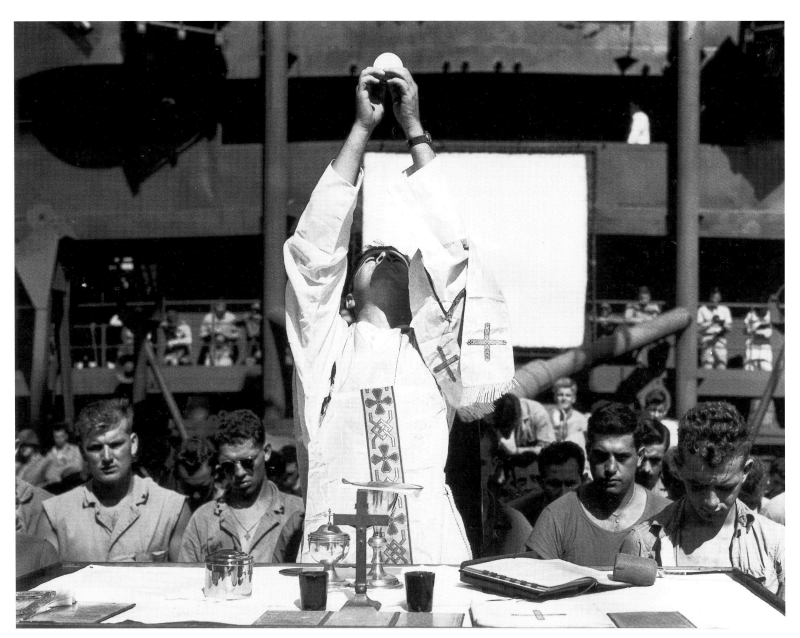

Briefing aboard Ship

As we approached Japan near the end of August, a colonel briefed us about our landing on the mainland. Watching his finger move up the coast on the map as he spoke, I anticipated the moment when he would point to the exact location of our landing—Sasebo—and snapped the photograph.

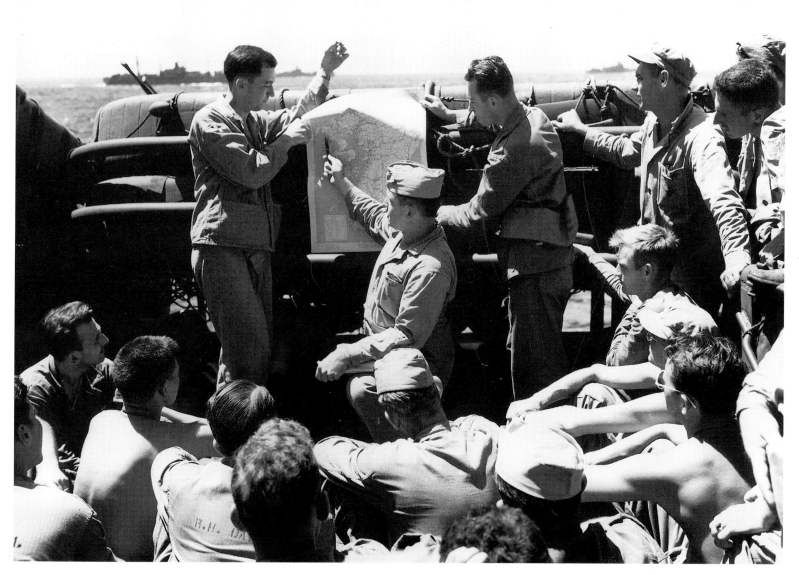

Landing

To take pictures of the ships arriving, I was ordered to go ahead in a small boat in hard rain and heavy seas to the beach. Waiting for the ships to appear, I realized how strange it was to be standing alone in Japan.

Then I heard a noise in the brush. A man appeared whom I recognized as a Japanese surgeon by his uniform and saber. He bowed his head as I approached and said in English, "I am a commander of Kyushu. I belong to the Imperial Army coming here to surrender." I was just a sergeant with no idea what to do. The man pulled out of his pocket some white material neatly folded into a twelve-inch square. I opened it and saw that it was a Japanese flag, what we called a "meatball."

Soon black dots appeared on the horizon. They grew larger very fast, and then the beach began to thunder with wave after wave of tanks and other heavy equipment rolling ashore.

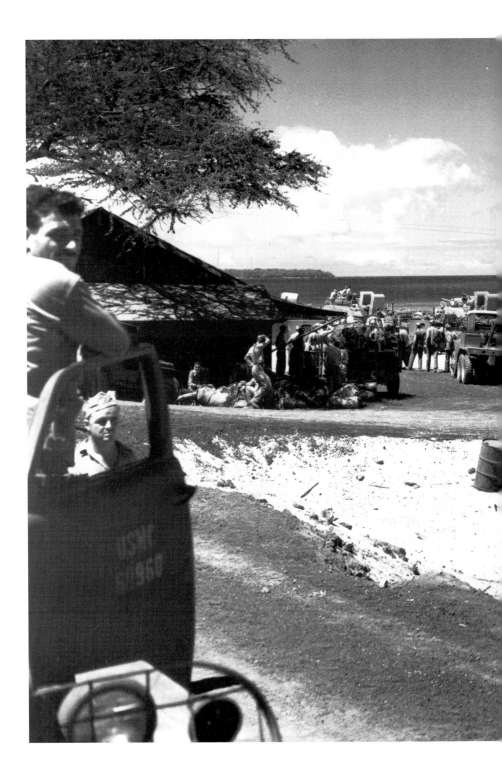

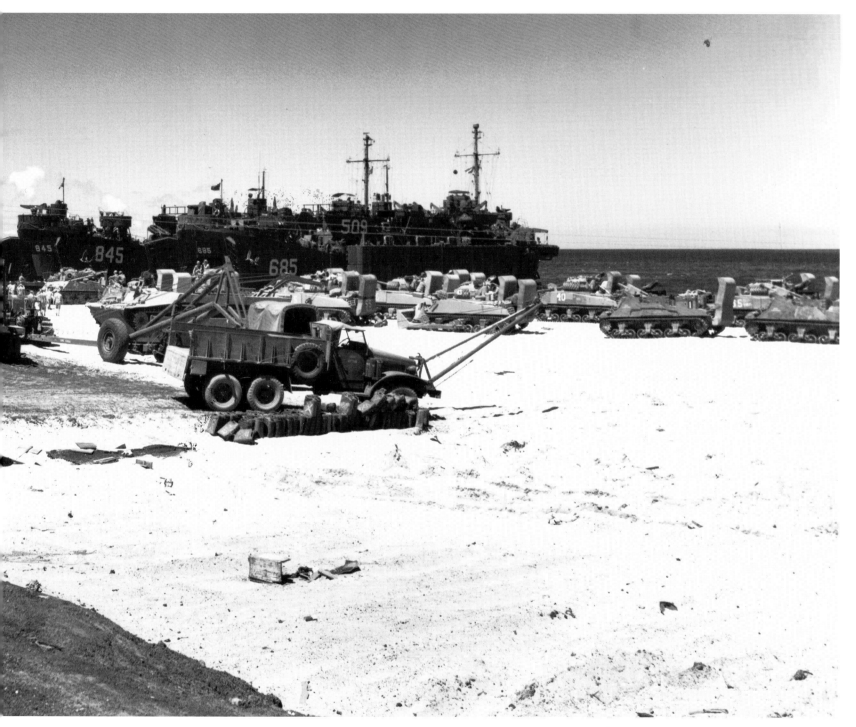

Sasebo

Sasebo Harbor

One of my first aerial photographs is this one of the Occupation ships in Sasebo Harbor. Here the American black ship armada is arrayed against a land of paddy fields carved into the hills rising from the sea. Staggered at the number of ships, I wondered how long the Japanese army would have lasted if we had gone through with the invasion.

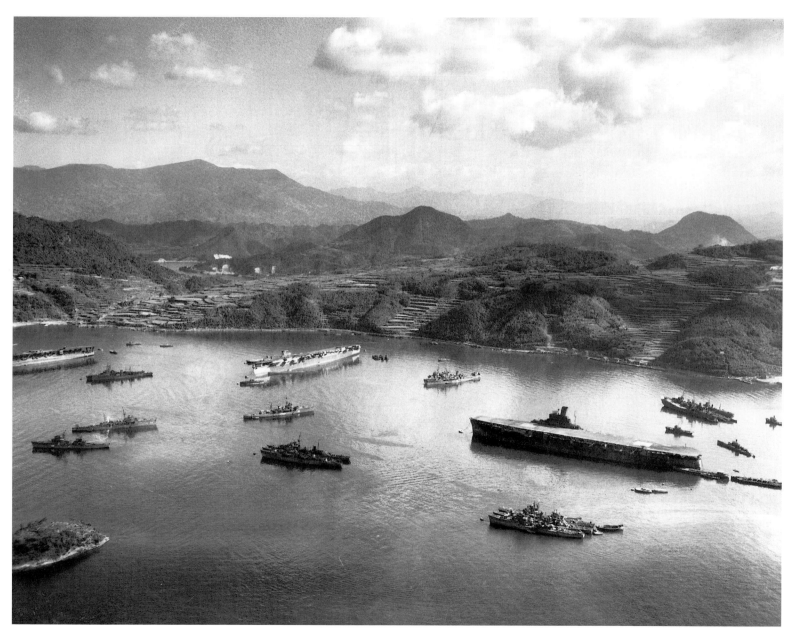

Joe in front of Tent City

Only twenty-four hours after landing, I stood in front of our tent city on Sasebo's beach. As far as the eye could see, there was nothing but rows of tents, each tent holding ten men.

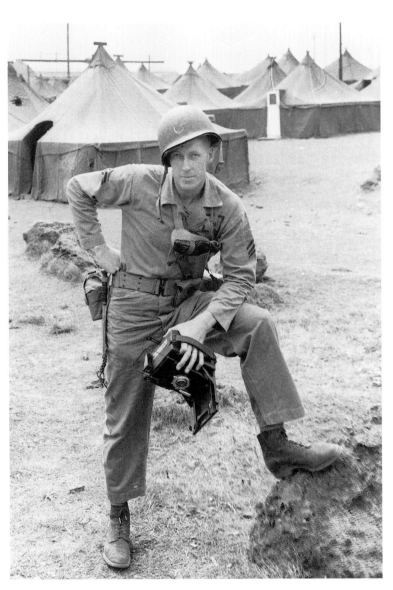

Standing on the Roof

From the roof of the tallest building in Sasebo, I have my first unobstructed view of the devastation caused by firebombs.

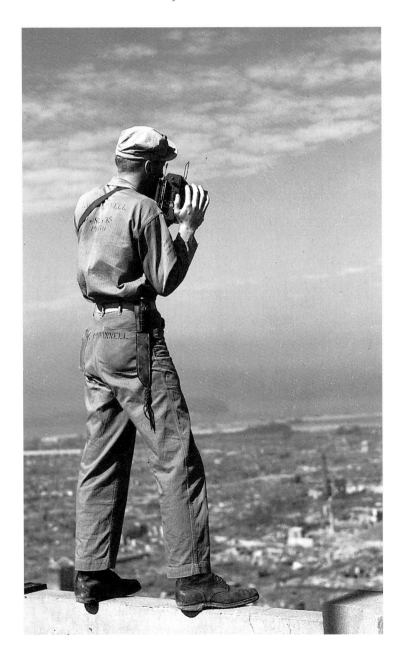

Sasebo, Aerial View

Japanese civilians fled the raging fires and sought shelter in high-rise buildings. On my way to the roof in the previous photo, I discovered that the high-rises had acted like huge ovens that roasted the trapped people. I raced to the top floor to escape the stench of the smoke-blackened bodies that filled the stairways and halls.

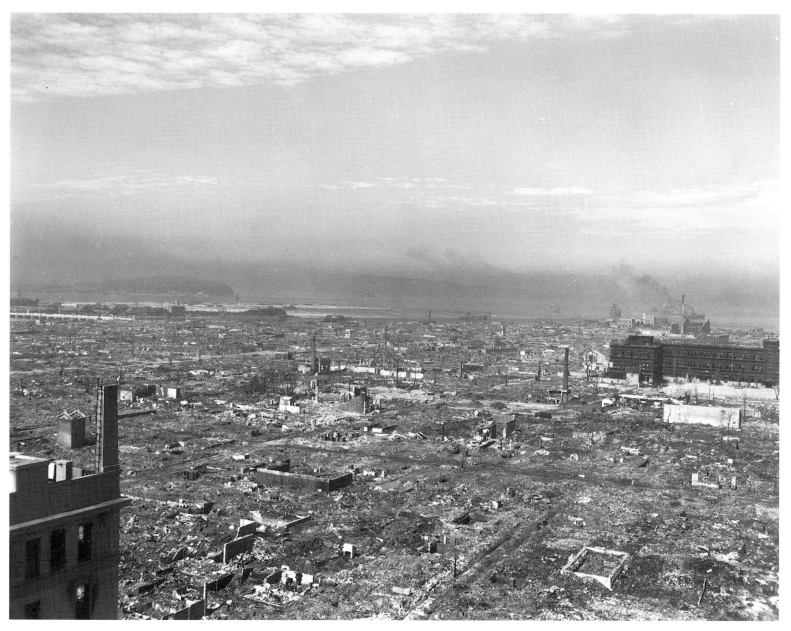

Ominous

Dark clouds and a deathlike stillness created an ominous feeling in downtown Sasebo.

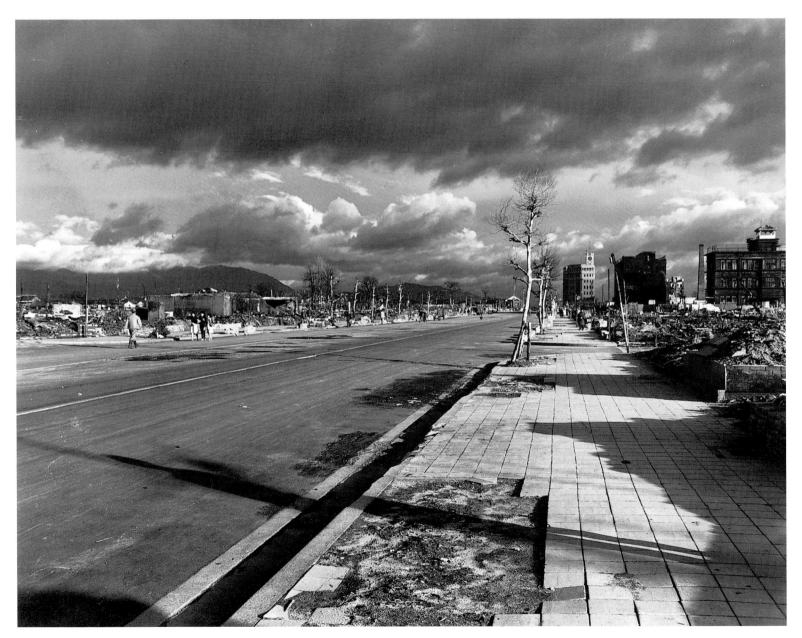

Displaced People, Sasebo

On the outskirts of Sasebo, this couple emerged from a heavily firebombed area. They carry what little is left of their belongings as they seek shelter with relatives or friends. The wife, carrying a child and the suitcase, stays a respectful ten feet behind her husband.

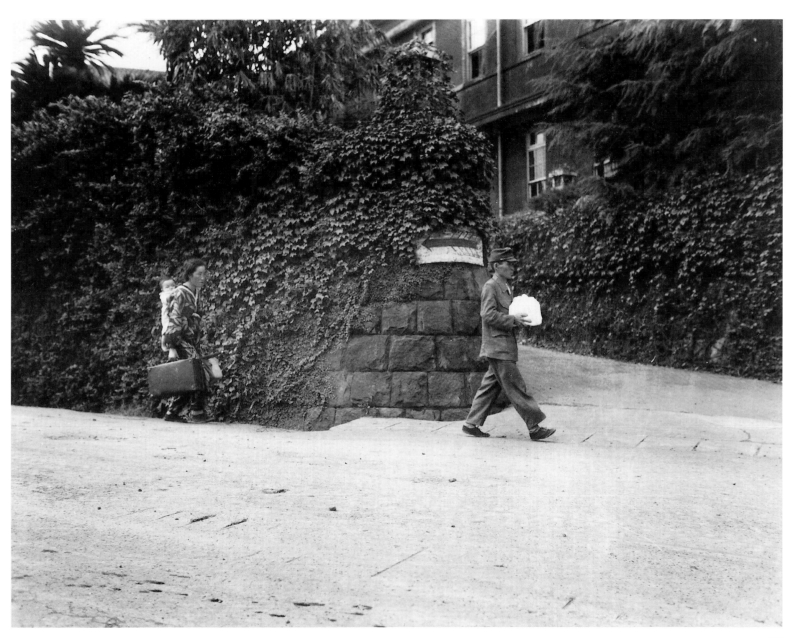

Moving

This family was moving to a house that had escaped the fires. On the cart are their *tatami* mats, which will completely cover the floor of their home. Since no shoes are worn indoors, these mats are kept very clean.

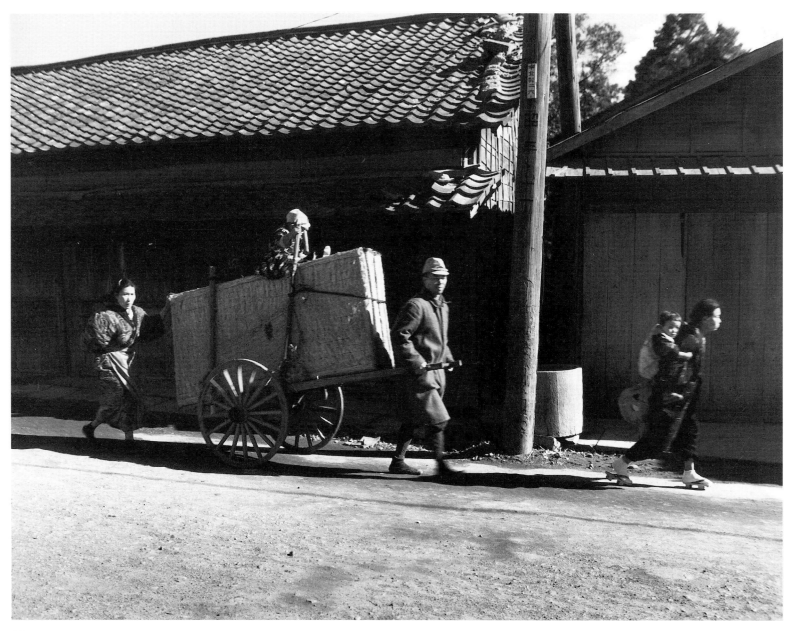

Back to Life

The dead have been removed. Now houses will be rebuilt, schools reopened, and food supplies made available. These women are returning with rations to their makeshift homes, and the child on one woman's back looks at me with open curiosity.

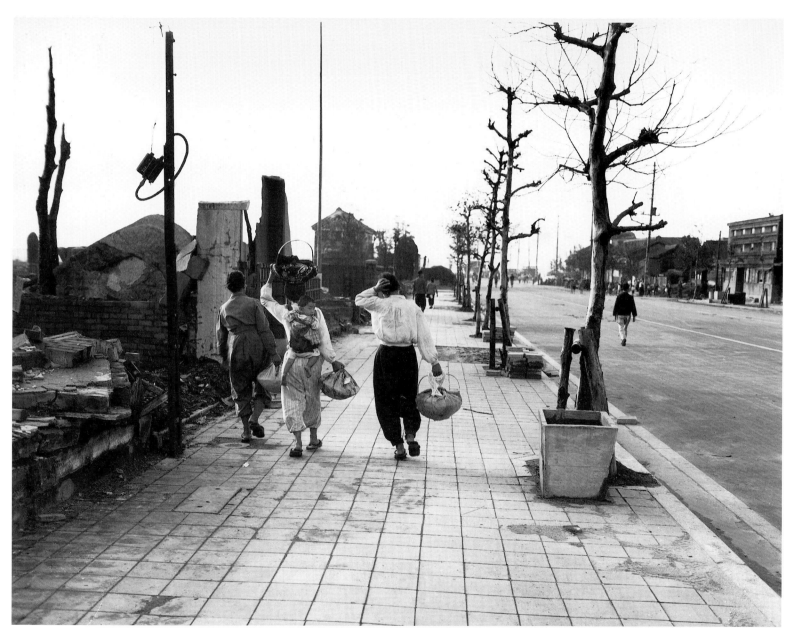

House Girls

These young Japanese women, called "house girls," worked as maids in the Marine barracks in Sasebo.

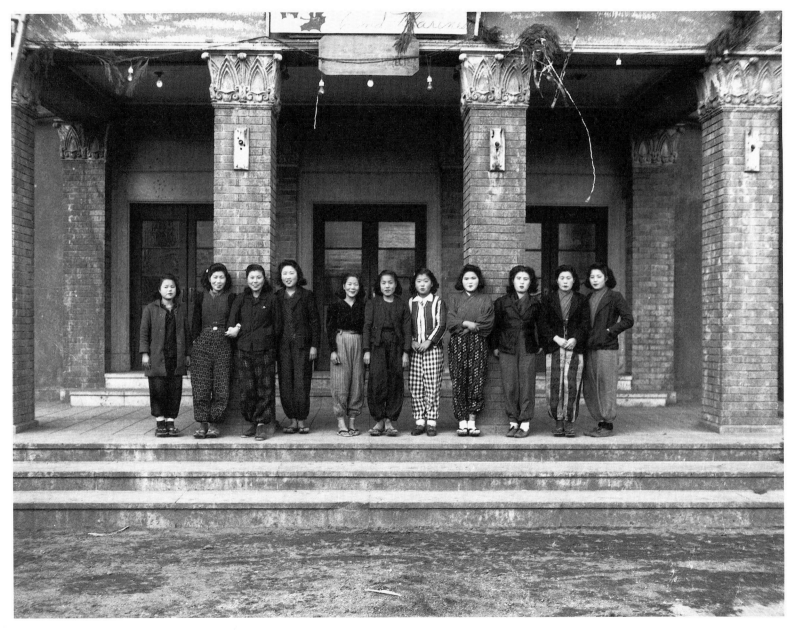

Huge Sign

As we filed past this sign, I mistakenly took it for a welcome to the Occupation Forces. Later I discovered that it called on Japanese civilians to honor and obey the Imperial Army.

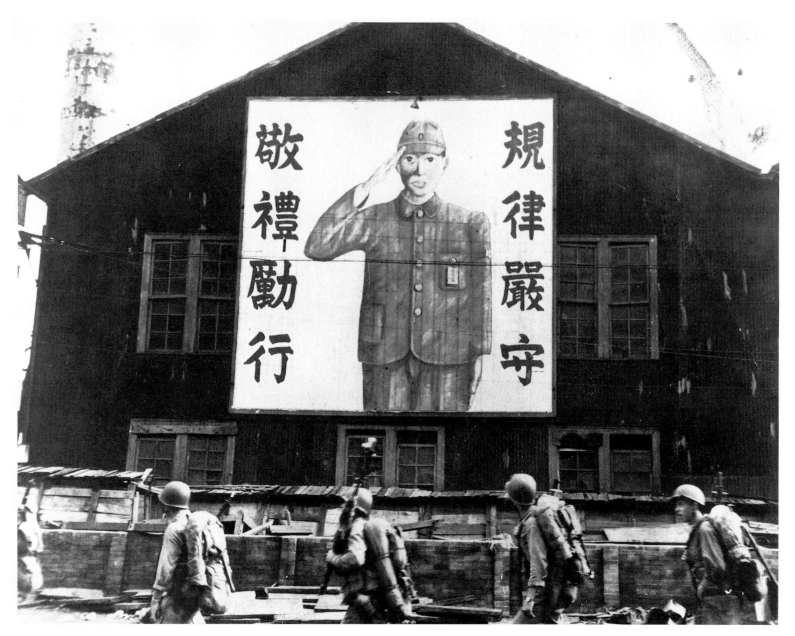

Marine and Children
Starving children soon discovered that Marines had chocolate and chewing gum in their K-rations. I often photographed this type of scene.

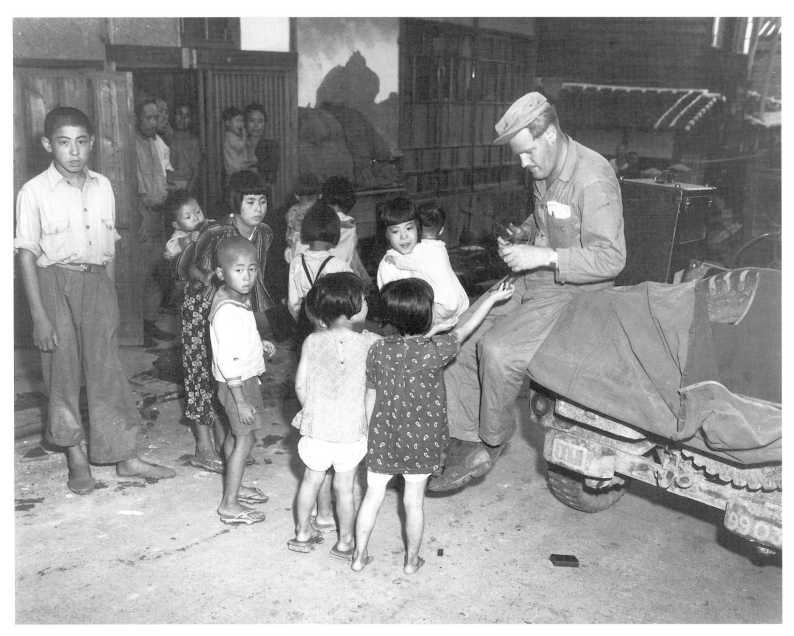

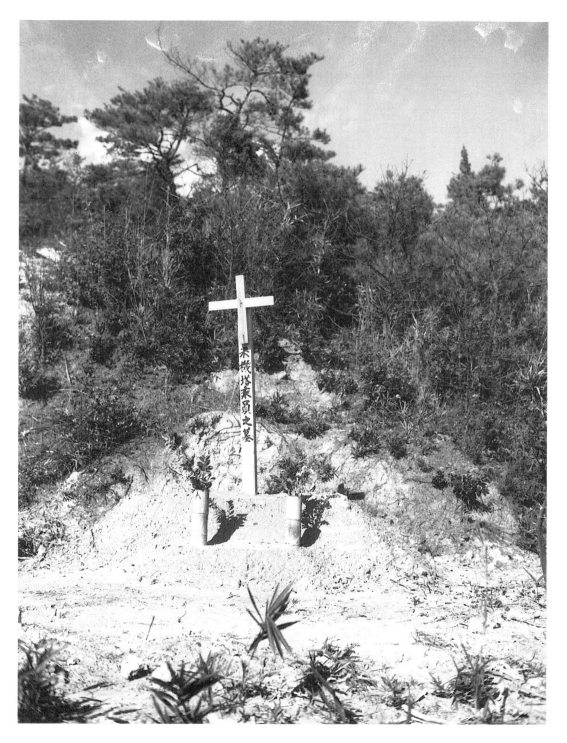

Grave of American Flyer, Yahata

My orders included finding out what I could about the fate of Doolittle's Raiders, the American pilots who disappeared after the first bombing raid on Tokyo. I soon learned that my cigarettes were good for obtaining information, and I discovered that a plane had gone down in the village of Takasu on Kyushu. Mr. and Mrs. Monza Aso were working in their rice fields when we drove up in our jeep. They told me that the pilot's parachute had caught in some trees on their land, and by the time they reached him, he was dead.

Near where the plane had gone down stood this simple cross with fresh flowers at the foot of the grave. It amazed me that the couple took such good care of an enemy's grave, and I said so. They responded simply that they respected the flyer as one of the dead. My interpreter told me that the markings read, "Grave of an American flyer, died September 16, 1944."

Mr. and Mrs. Aso, fascinated by the fact that the Nisei boy who acted as my interpreter was American, invited us to dinner.

Plane Wreckage

Mr. and Mrs. Monza Aso bring out pieces of a U.S. pilot's airplane, salvaged from the wreckage near their home.

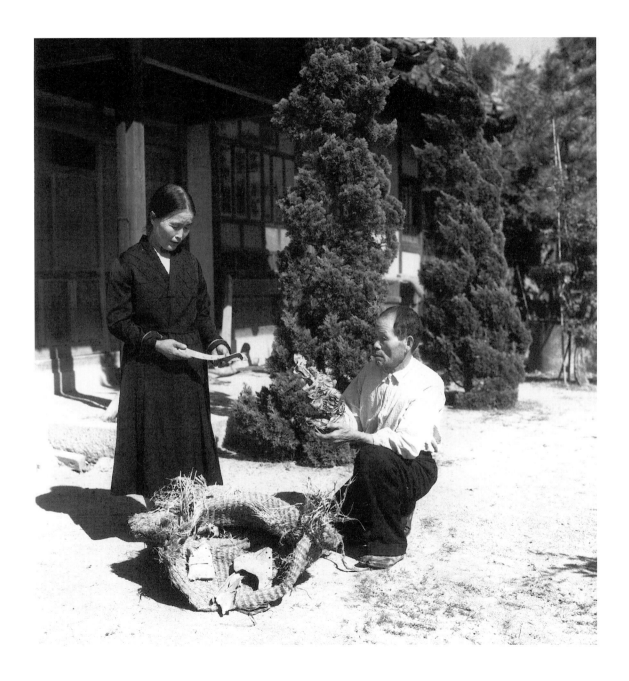

Rice Harvest

Having never seen rice harvested, I was struck by the amount of labor involved in the process. This man carefully hangs up each stalk on a wooden drying frame. Hundreds of these frames line the fields. Husband and wife required several days' labor to cut and dry the rice.

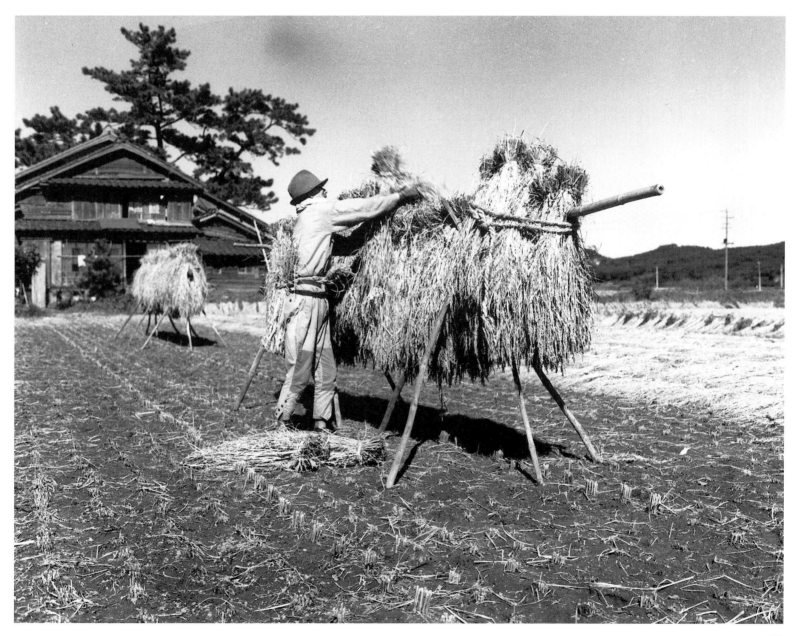

Passing the Cremation Site

While taking pictures of cremations along the river bank, I saw these three young women walking down the road towards me. The stench of burning flesh and hair coming from the site was enough to make me sick, and I sympathized with their attempts to keep out the smell by covering their noses and mouths with their scarves.

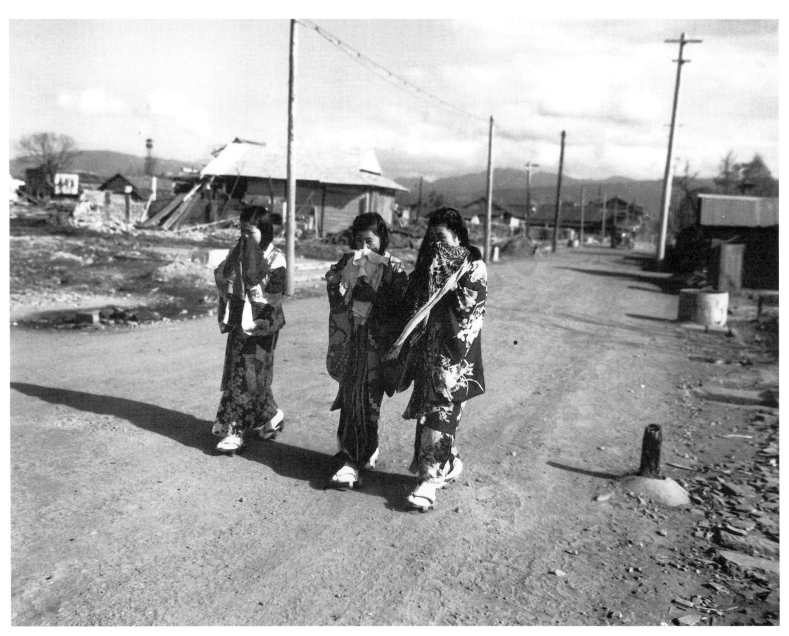

Fukuoka

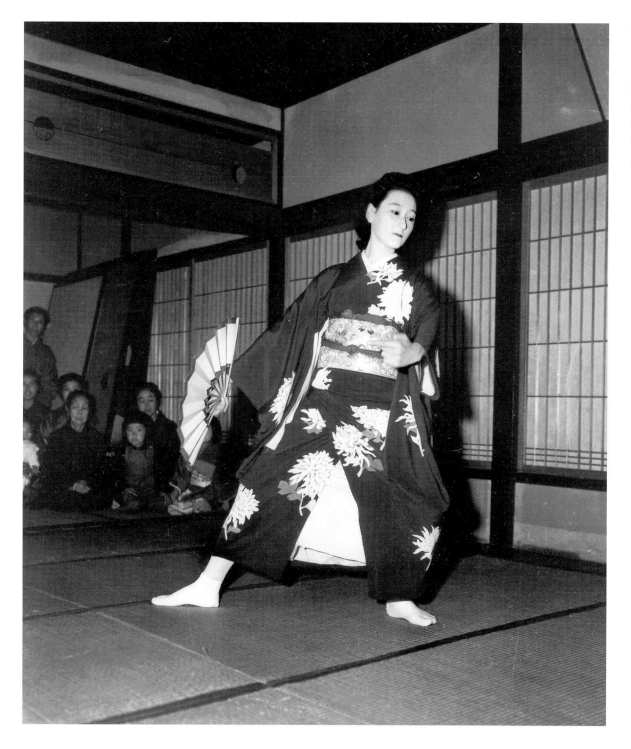

Geisha Show, Fukuoka

This was my first experience with the precise, graceful movements and rich costuming of traditional Japanese dance.

After the Show

After the show at the Hakata Hotel in Fukuoka, these geishas pose for a final picture.

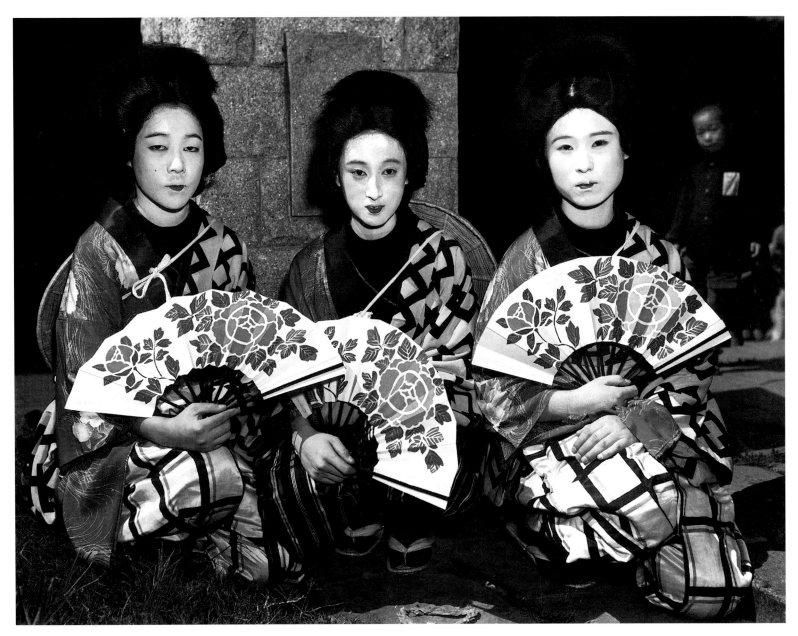

Shoes

Marine boots mingle with Japanese sandals at the entrance of a local church. In a house of worship, the two sides of the war finally came together in peace.

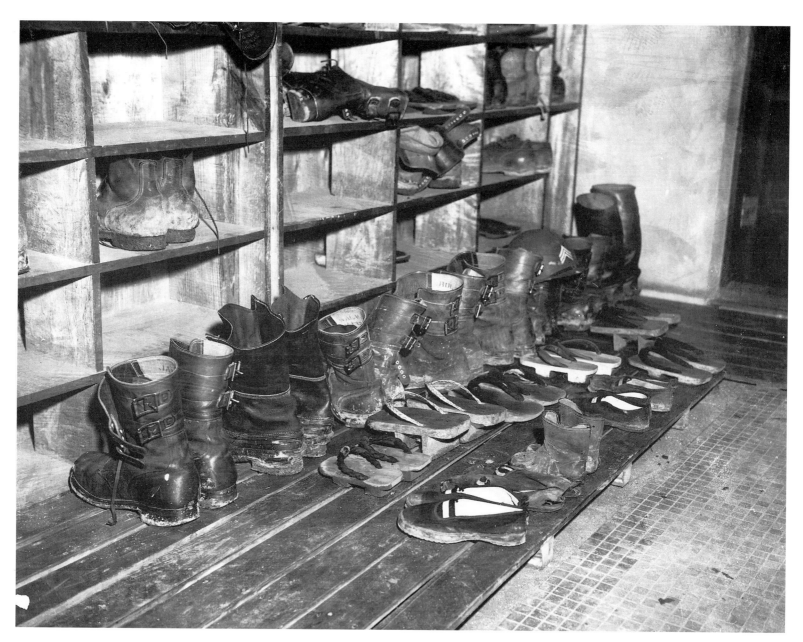

Dinner Party

As guests of the local chief of police, correspondent friends and I were treated to dinner and then a hot tub bath. The food was delicious, although most of the time I didn't know what I was eating. To the amusement of my companions, I had trouble sitting on my long legs, so I left them stretched out. Since I then usually hit someone on the opposite side, I was always seated at the end of the table.

At another dinner with the mayor and eight Japanese men, I wondered about who had cooked all the delightful dishes and asked him if he were married. "Yes," he replied quietly, "for thirty-five years." I asked if his wife had been slaving away in the kitchen and whether we could meet her. The translator listened to the mayor's response, then made an odd sound by sucking in his breath through his teeth. "What did he say?" I repeated several times. The young man lifted his head and looked into my eyes. "He say your bomb killed her a month ago."

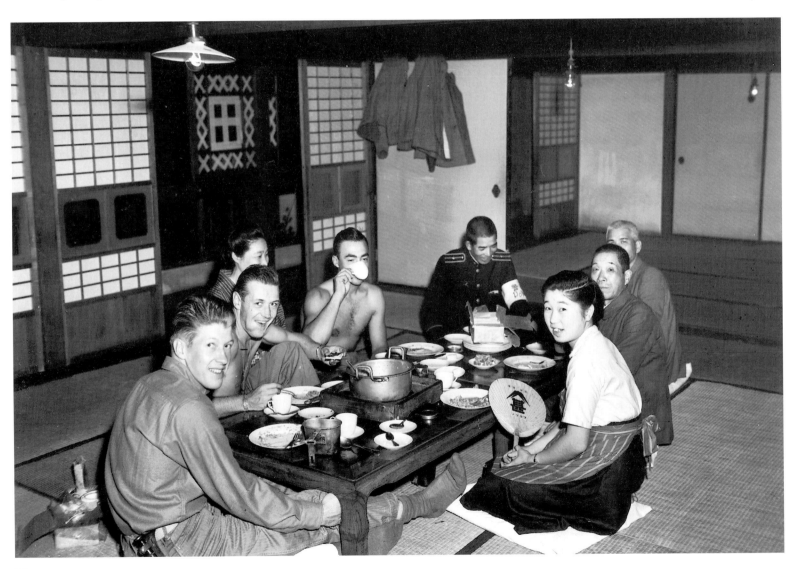

Hotel Hot Tubs

Following dinner, my friends and I were offered a hot bath before bed. Opportunities to bathe were rare, so we wanted to commemorate the occasion with a picture. The water was so hot that we had to ease ourselves into the tub.

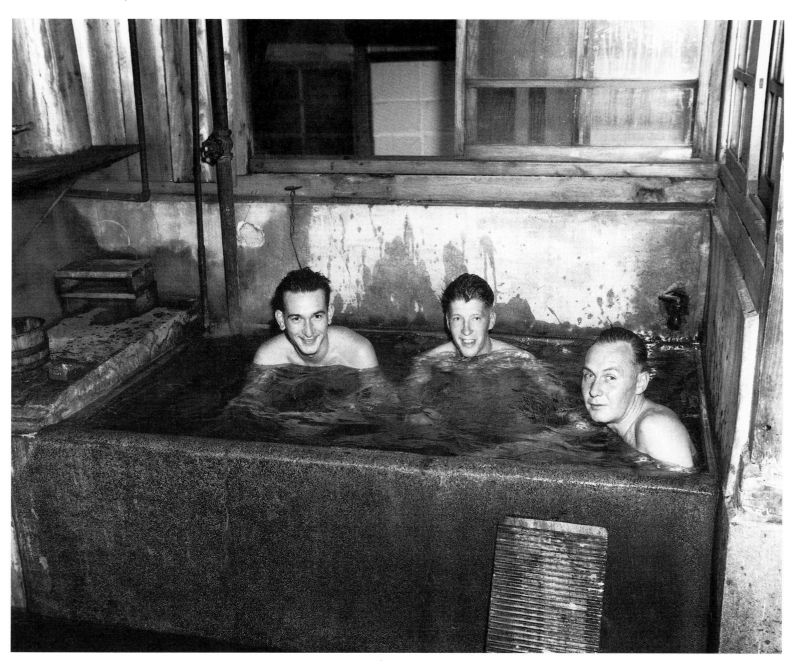

Hotel Maids and Marines

Using the timer, I photographed us with our maids, whose services were included in the cost of the room. Initially we were confused as to their function, wondering if they were prostitutes. We were surprised when the women prepared our beds, cleaned the room, and after sleeping behind a large screen prepared our breakfast. The only unpleasant surprise was discovering that our pillows were blocks of wood covered with cloth.

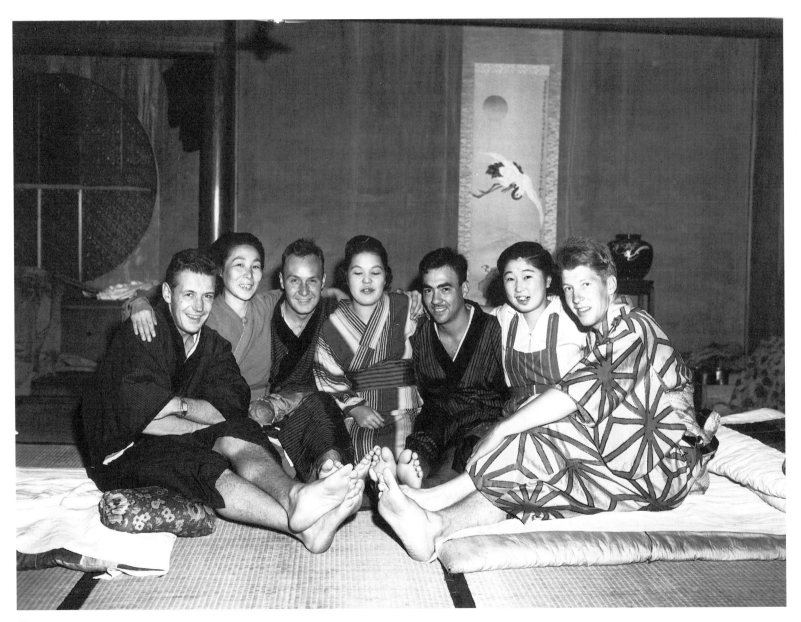

Street Scene, Fukuoka

While photographing some street scenes, I came upon this line of people. I thought perhaps they were waiting to see a movie. The people were entering a store, where in very orderly fashion each received one loaf of bread. Since no money was exchanged, I wondered who supplied the bread, the Americans or the Japanese.

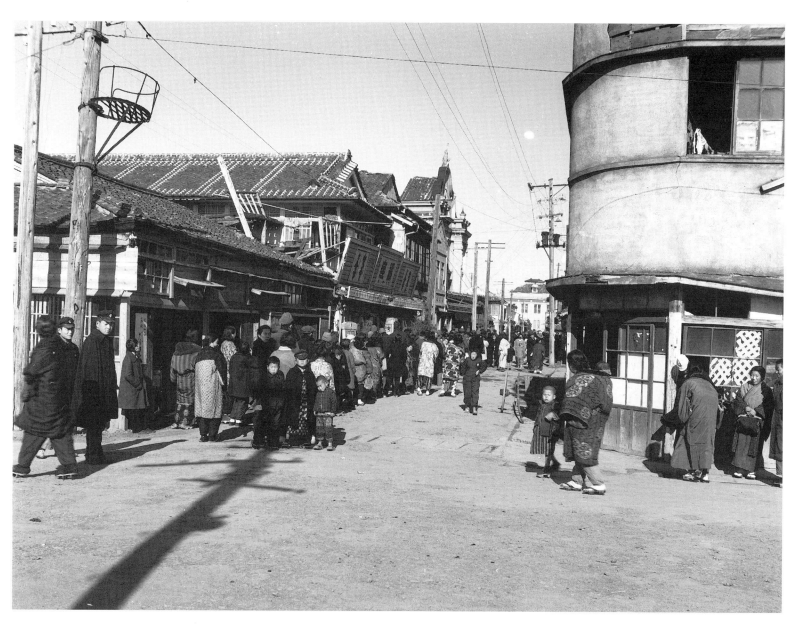

Firemen

I came upon these firemen on the roof of a building that was engulfed in flames. I was taken by their colorful decorated lanterns and their high-pitched chant. I later found out that they were burning down some of the buildings that had been damaged by the fire bombs. The fire was out of control and their water hoses had been burned in the bombing, so there was no way of getting water to the scene. The writing on the lanterns identified Fukuoka's Fire Company Number 8.

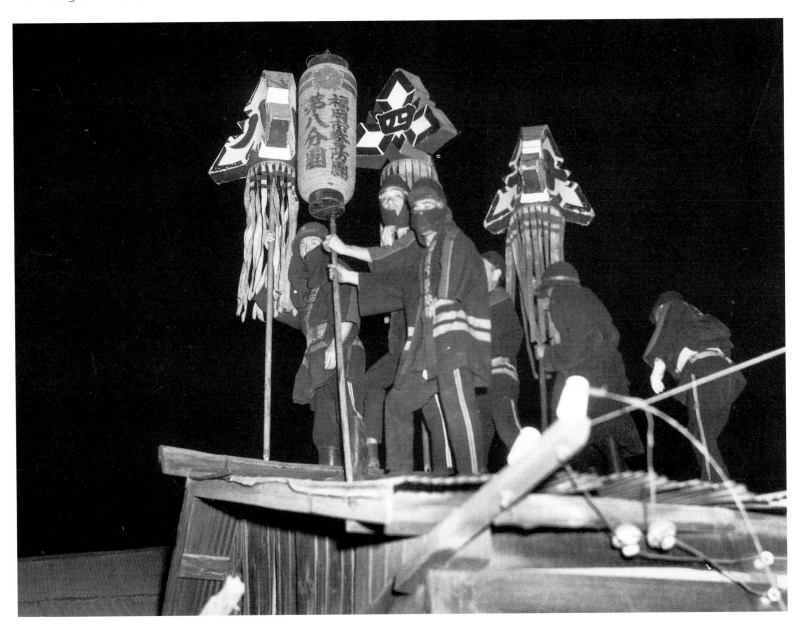

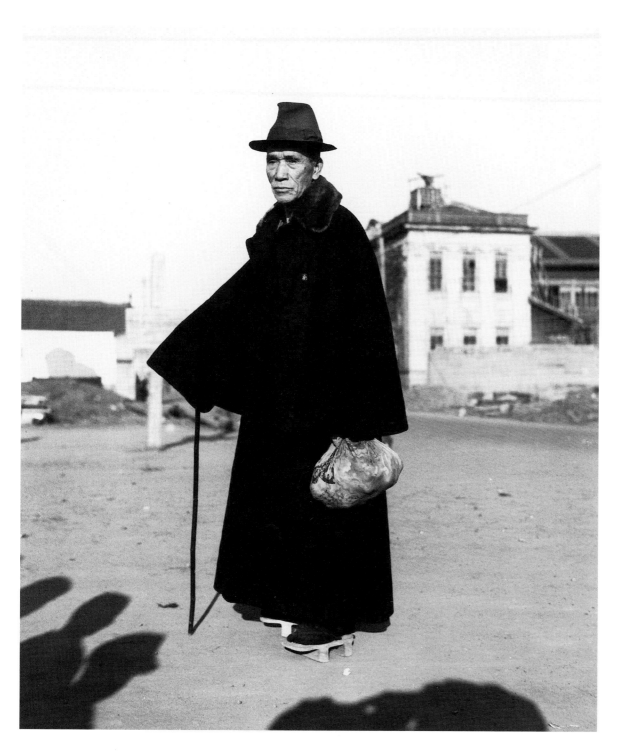

Old Man

This man's unusual western-style long coat and hat caught my attention, so I snapped his picture. I was accustomed to having simple questions asked by people I photographed, but this man astonished me by not only sharing information about his past (he had lived in the United States but was caught in Japan while visiting family when the war broke out), but by commenting on the atomic bombings. "I lost my entire family and most of my friends. They were like you and me, innocent ones, and they did not deserve to die. I can forgive America, but don't ask me to forget. Like planting seeds in the dirt, buildings will rise out of these ashes, but unfortunately not in my lifetime. You tell your people what it was like after the bomb." His words haunted me in the months that followed.

Police
Surprised to see any uniformed Japanese, I asked these officers to pose for a picture. At first they were reluctant, but after I offered them cigarettes and Hershey bars they proudly stood at attention.

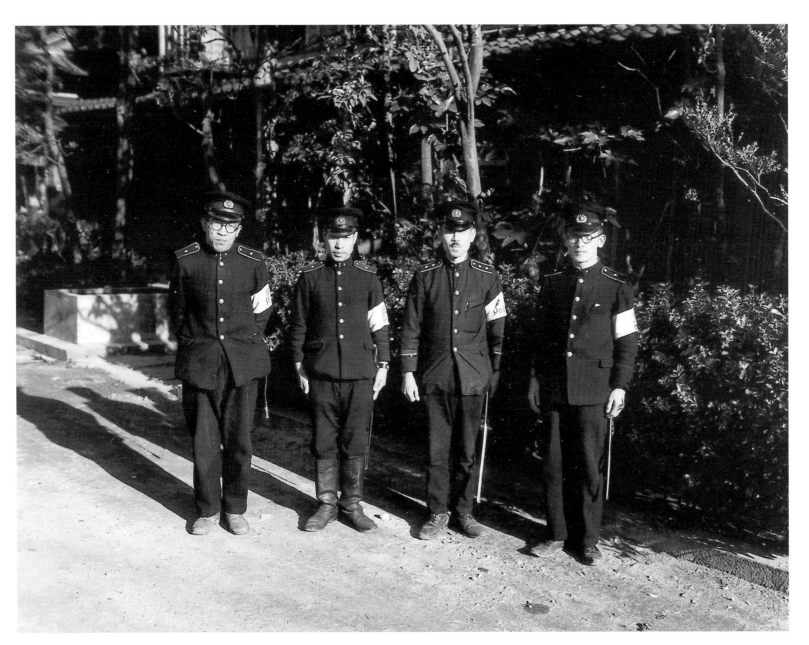

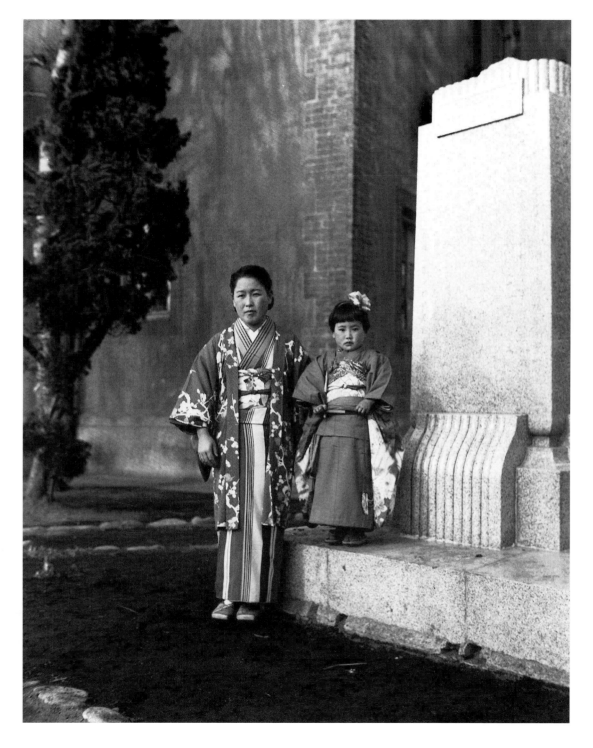

7-5-3 Day, Fukuoka

Mother and daughter dressed for Shichi-go-san, a November 15 festival. Seven- and three-year-old girls dress in their best kimonos and five-year-old boys dress up as well (today in suits).

Haircut in Fukuoka

Small girl has her forehead shaved along the hairline in popular Japanese fashion.

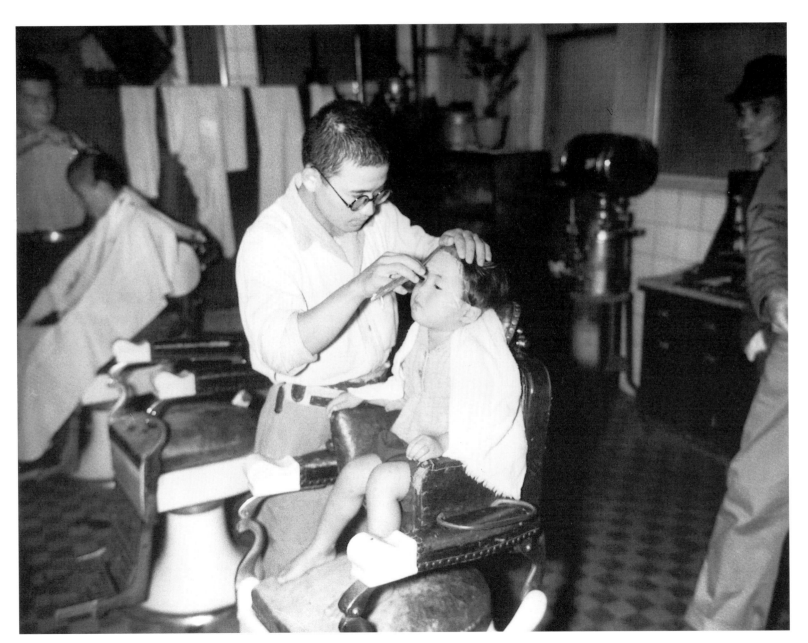

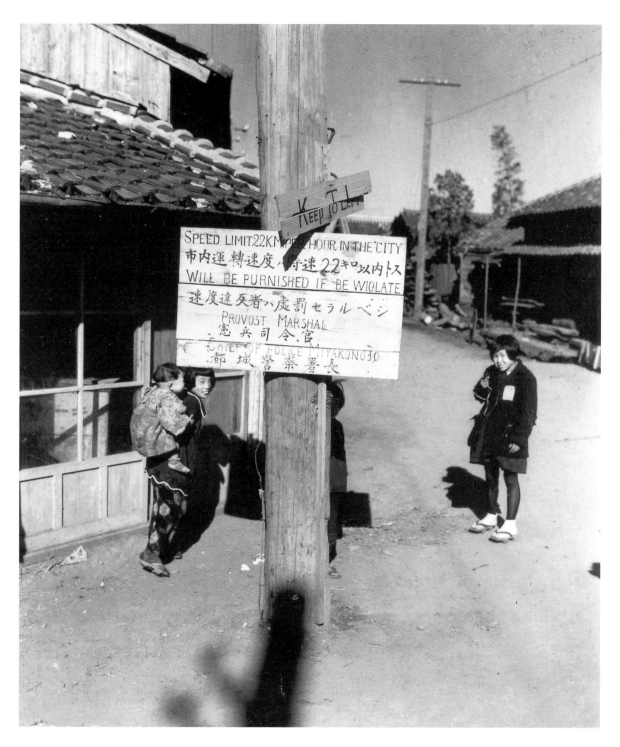

Speed Limit

The ever increasing number of American jeeps led to the posting of speed limit signs. More difficult than obeying the speed limit was remembering to drive on the left instead of the right as in the U.S.

Athletic Day, Fukuoka

From a hill I noticed what I at first thought were military exercises in a nearby field. To my surprise, the participants were all children. Their team relay race required crawling through the ladders.

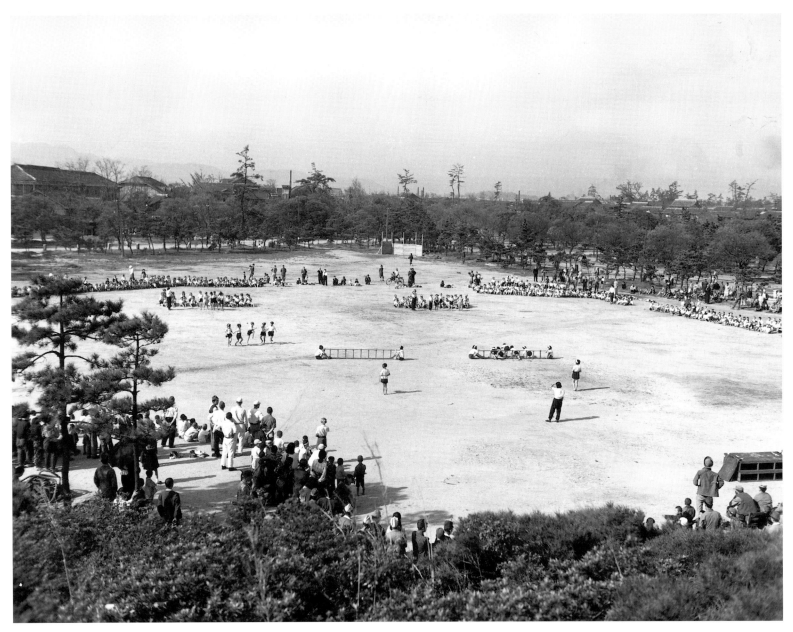

Spectators at Athletic Day

Descending from the small hill at the upper right, I found myself in the crowd of spectators. It struck me that there were very few adult men—only women, children, and a handful of elderly.

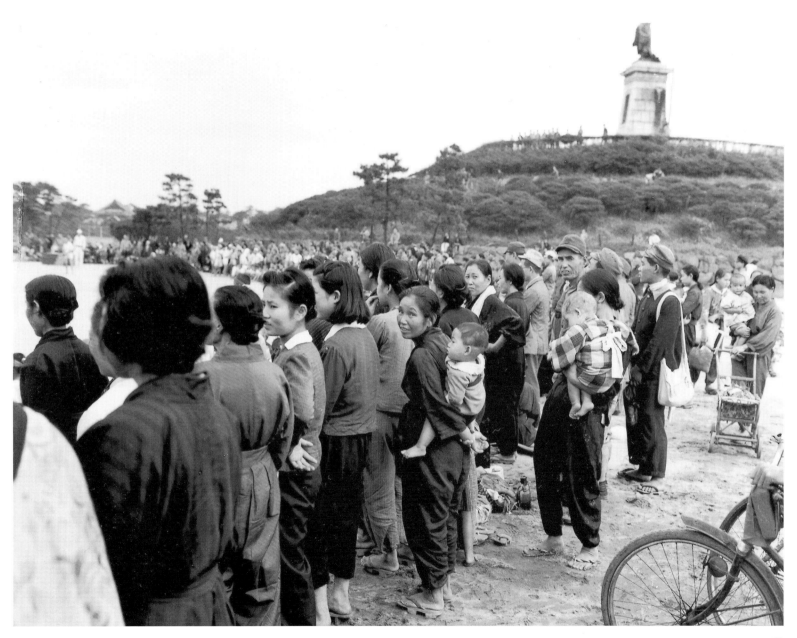

Children Playing

I was happy to take a picture of these children, who were playing on the road with obvious pleasure.

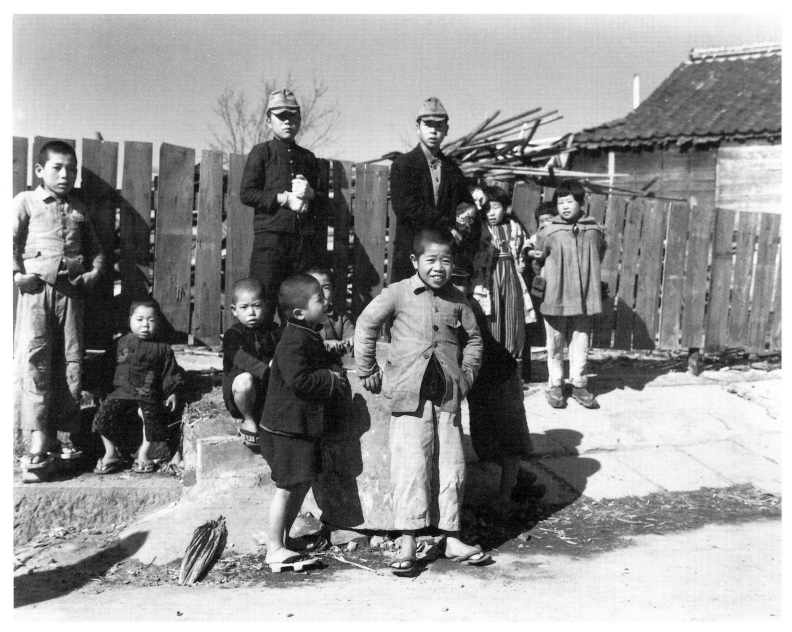

Children Working

These young children worked as road cleaning crews. Their tools were a handmade rake and a broom made by tying brush to a pole. Many children worked without shoes or sandals. I never saw an adult supervising them, but they were always working, never tiring or stopping to play as I would have expected.

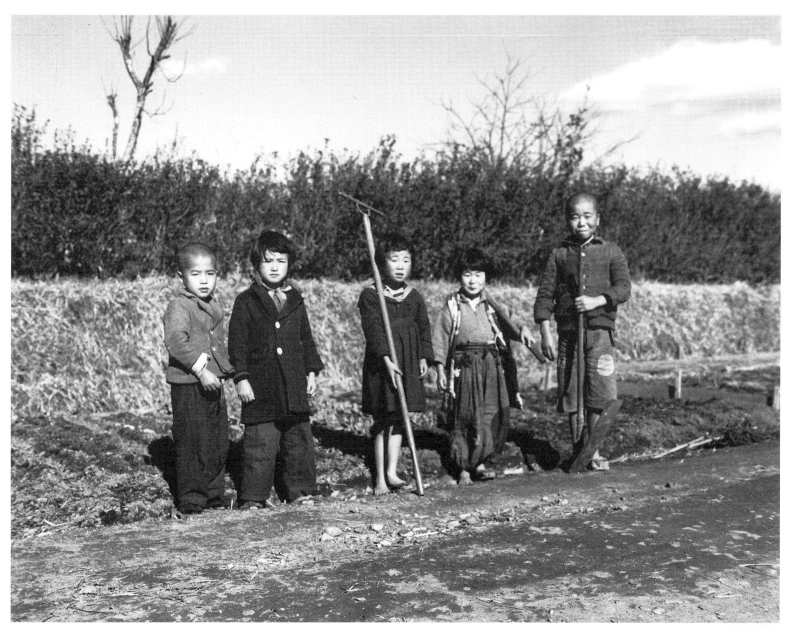

Schoolhouse

Not a single child can be seen or heard around this gutted schoolhouse.

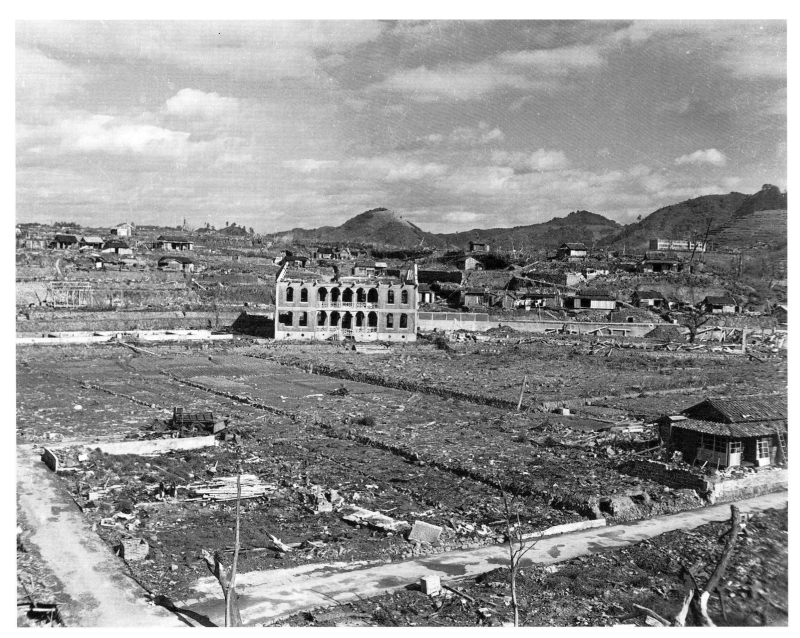

Babysitters

I was surprised to see such young girls all carrying babies on their backs. Carrying the babies never seemed to interfere with their day-to-day activities. Almost all the schools were destroyed by the bombs, so these girls cared their siblings while helping their parents or working on road cleaning crews.

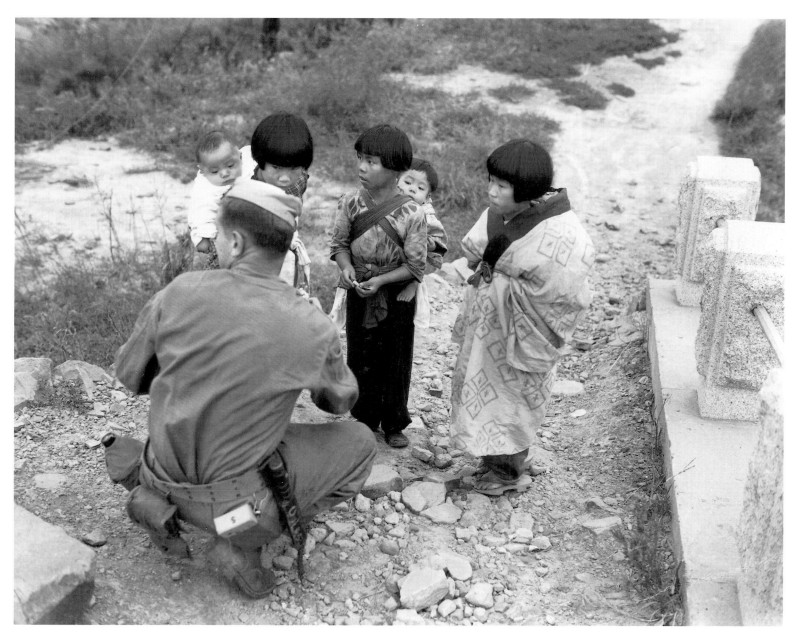

Typhoon-Damaged Plane

On a beach north of Fukuoka I climbed on top of this typhoon-damaged pontoon plane.

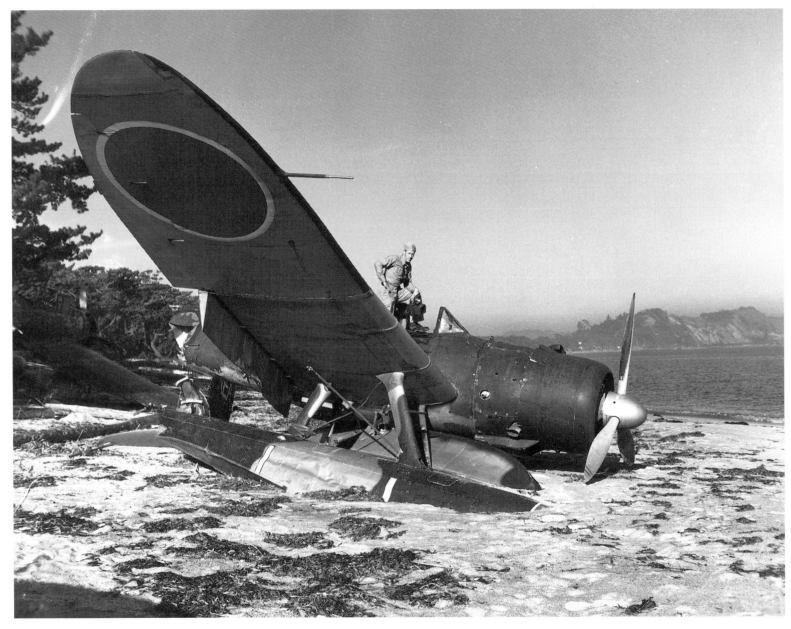

Kamikaze

While visiting some air fields before the Marines burned all the Japanese airplanes, I talked to a former Kamikaze pilot instructor. In surprisingly good English he told me that the Kamikazes did not want to fly towards the end of the war. He spoke about his nineteen-year-old brother, one of his instructees, who flew his suicide mission just days before the war ended. He offered the opinion that the Emperor was dishonored because the war was lost.

Every Kamikaze pilot decorated his plane with a special picture. This pilot chose a depiction of his plane destroying a ship.

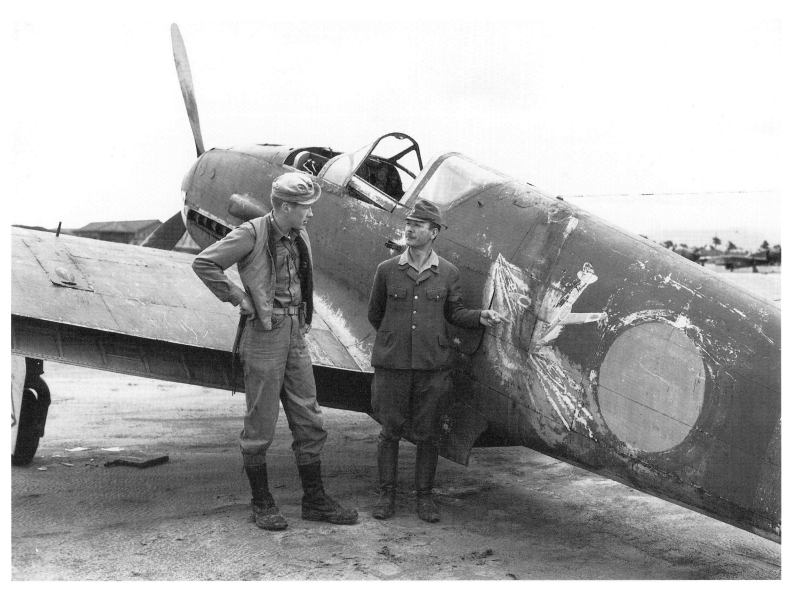

Airplane Mound, Fukuoka

I was assigned to photograph the destruction of all remaining Japanese aircraft on Kyushu. Airplanes, bulldozed into huge piles at Fukuoka airport, were surrounded by wooden boxes and crates. Prior to the dousing of gasoline on the boxes, I climbed up onto an aircraft wing and looked into the cockpit. Everything inside was intact. It seemed a terrible waste to burn the perfectly good instruments and equipment, but this assured that the planes would never fly again.

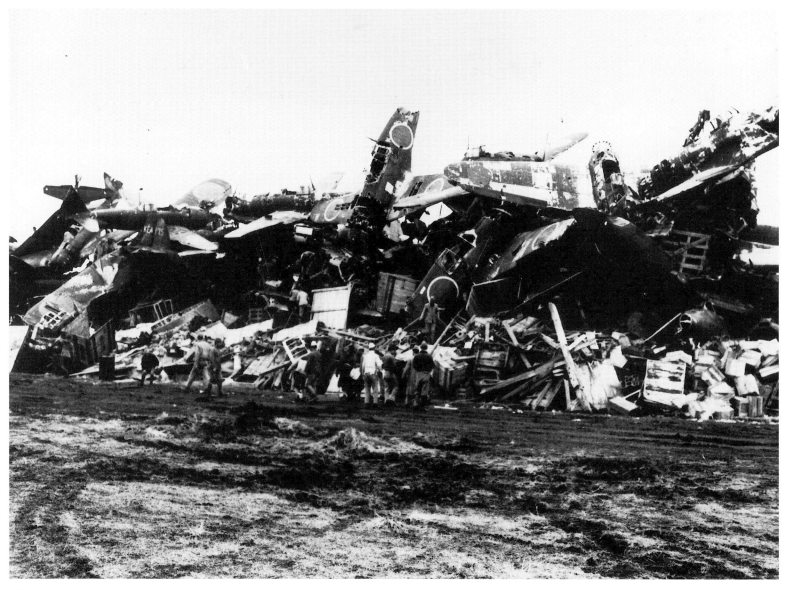

Torched Airplanes

The planes went up in flames instantly; tremendous heat and thick black smoke drove me back. I left the airfield after taking this picture. Only 400 Japanese airplanes were left at the end of the war.

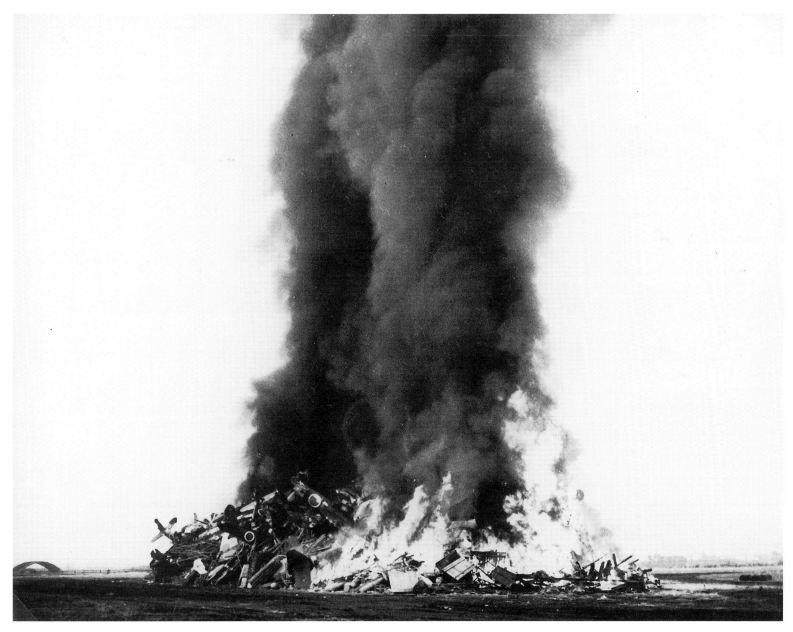

Developing

My official photographs were sent on to Pearl Harbor undeveloped. I developed my personal photos almost daily in makeshift labs in tents, empty rooms, or demolished houses. Thanks to my training at MIT prior to my assignment to Japan, I understood the process of developing enough to make field labs using whatever I could find. At one point I resorted to using my helmet and liner for the chemicals and a nearby stream for washing the negatives, hanging them on trees to dry.

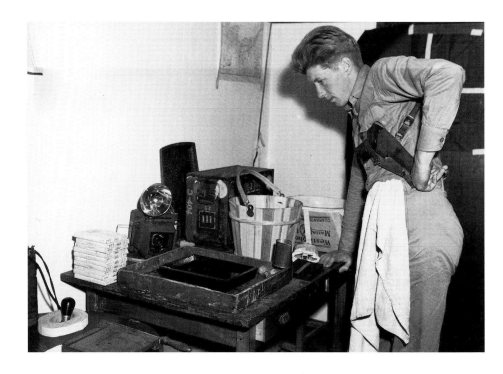

Honor Guard

The chaplain and the Base Commander lead the Honor Guard. The casket holds the remains of one of ten Marines killed the night before by a train at an unmarked crossing. An airplane waits to transport the bodies back to the U.S.

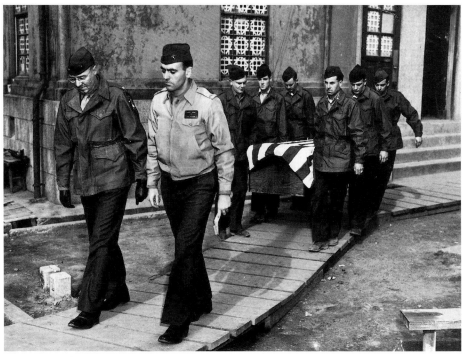

Hiroshima

Fake Cannon, Hiroshima

While flying over Japan, I saw many cannons lining the coast. Later I traveled by jeep between Sendai and Tokyo to photograph them. They were not cannons. They were light poles, concrete blocks, and pieces of wood put together to fool the invading U.S. forces. The false bunkers were nothing but sand etched to look formidable. I went from cannon to cannon, covering many miles. I didn't find a single real artillery piece, nor any location from which one might have been recently removed.

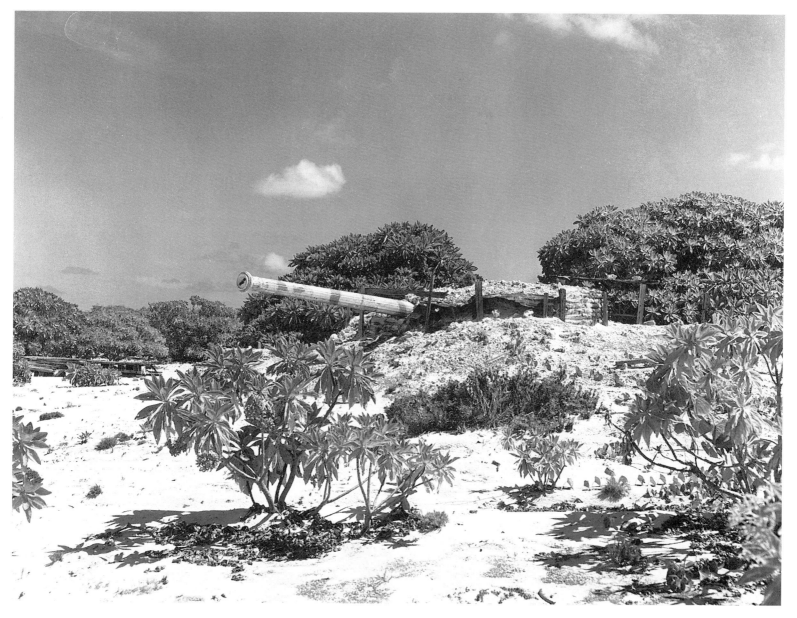

Hiroshima, Aerial View

One lone person walks near the ruins of Nagare-kawa Church 450 meters from Ground Zero. This is one of several low-altitude aerial pictures I took showing the complete destruction of the city.

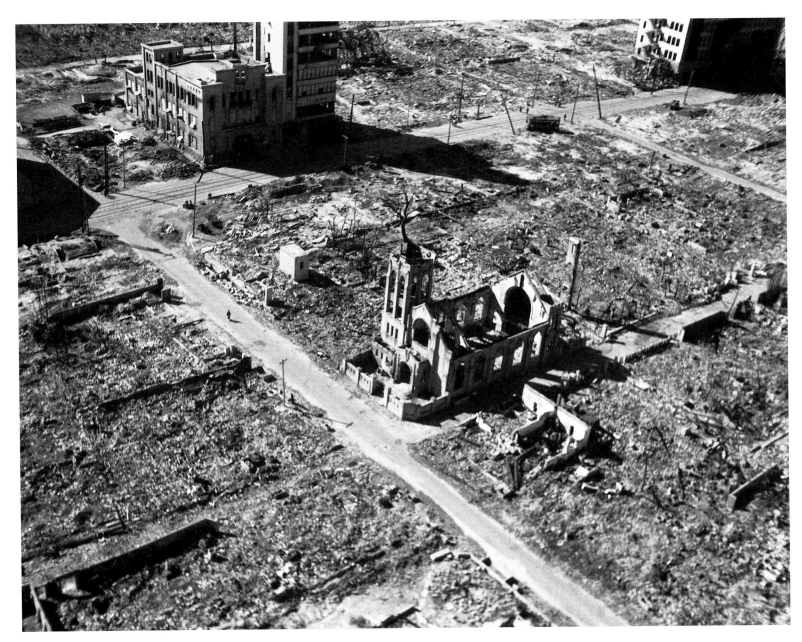

Aioi Bridge

August 6, 1945, 8:15 A.M., Hiroshima. One lone concrete building stands with the Aioi Bridge, the target for the first atomic bomb. The Enola Gay missed the target by 800 feet and instead the bomb detonated 1890 feet over the Shima Clinic, a small private hospital. Stone columns flanking the hospital's entrance were rammed straight down into the ground; the entire building collapsed, and the occupants were vaporized. In that same instant 90 percent of the city's buildings became rubble and 4.1 square miles of land was destroyed.

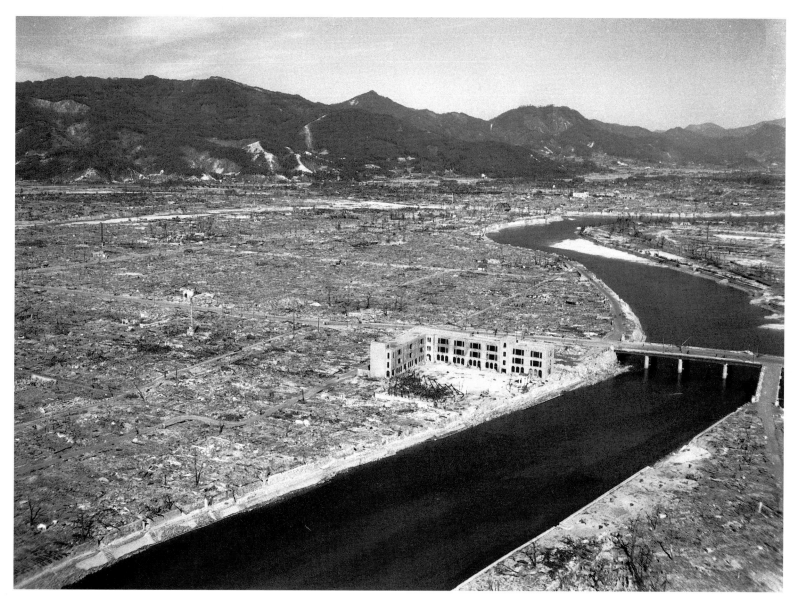

Joe on His Horse

The Nisei boy photographed me astride Boy on a Hiroshima hillside. Unlike my jeep, Boy traveled easily through the rubble in the demolished cities. He was my constant companion for almost four months.

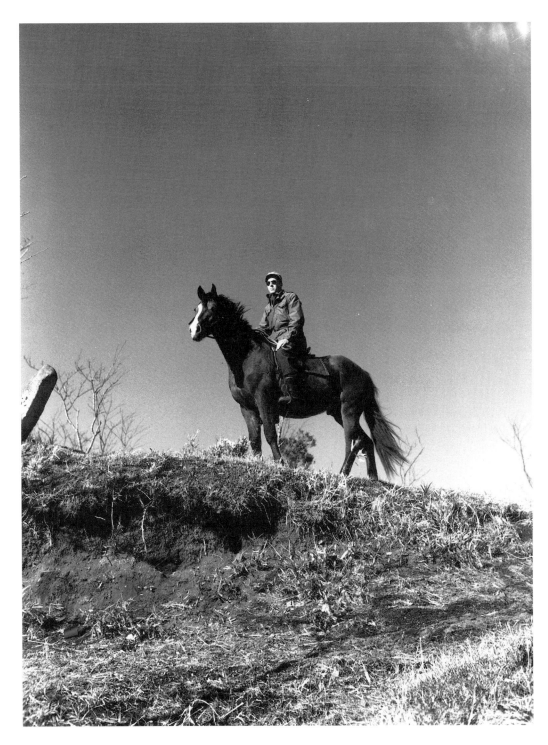

Nagasaki

Aerial Views

In order to obtain aerial views of the cities, I befriended Marine pilots whenever possible, taking pictures of them with their planes to send home to their families. In order to obtain unobstructed views of the ground, we folded down the doors of the plane. On this day, I was making aerial shots of Nagasaki, and I was stunned by the amount of destruction.

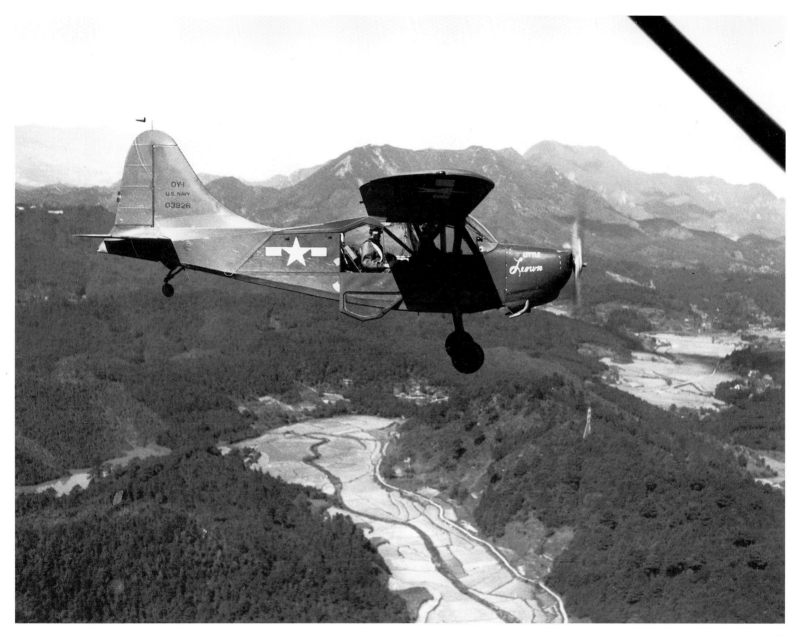

Airstrip and Highway

Clearly seen here are a white road (National Highway Number 206) and the railroad tracks on the right side of Nagasaki. The flat area in the lower right is the new Marine airstrip called "Atomic-Field" by the Marines who built it.

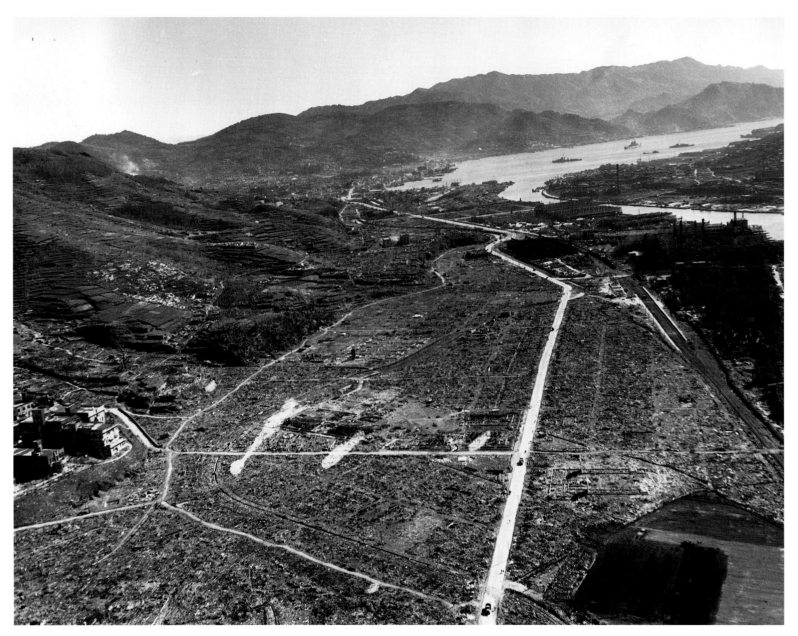

"Atomic-Field"

"Atomic-Field" was the ironic name given the U.S. Marine airstrip in Nagasaki. At the time no one knew how much radiation was in the area, nor what kind of hidden death lurked there. Hundreds of apparently healthy Japanese people died mysteriously months after the bombing, and strange ailments afflict survivors today, both Japanese and American veterans who served in and around Hiroshima and Nagasaki.

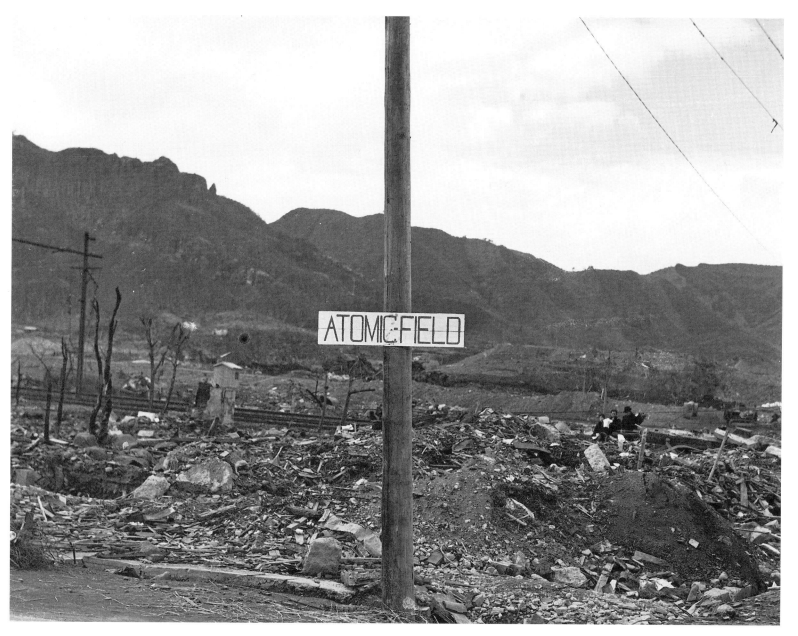

Returning Home

Remnants of the Imperial Army return to the devastated city of Nagasaki, their only possessions piled high on a horse-drawn wagon. I could see that they were shocked at the sight of what the atomic bomb had done to their city.

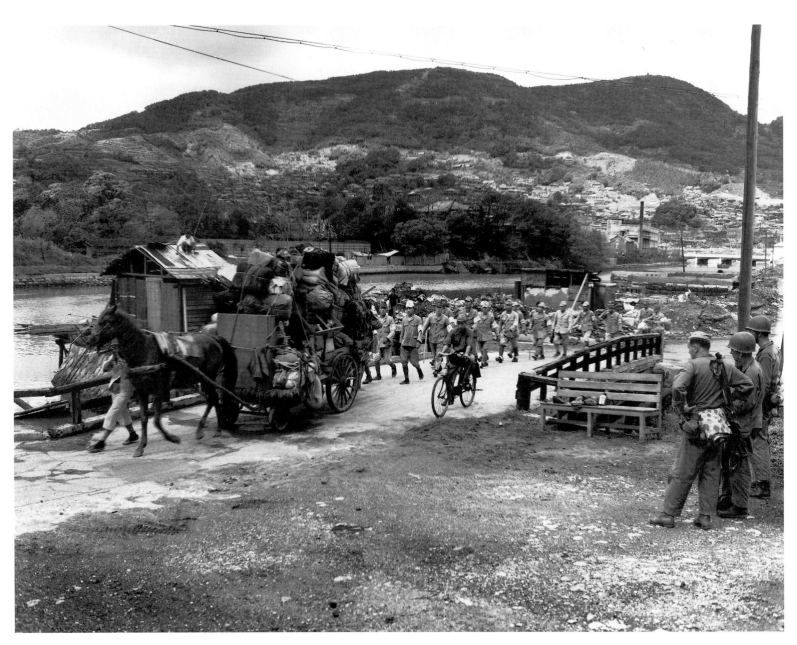

Tangled Wires

Looking from the outlying area of Nagasaki towards Ground Zero, all I could see still standing were these concrete buildings, bridges, and wooden light poles. The force of the blast probably bent these poles over, but as the force passed beyond them they returned to an upright position, leaving the wires a tangled mess.

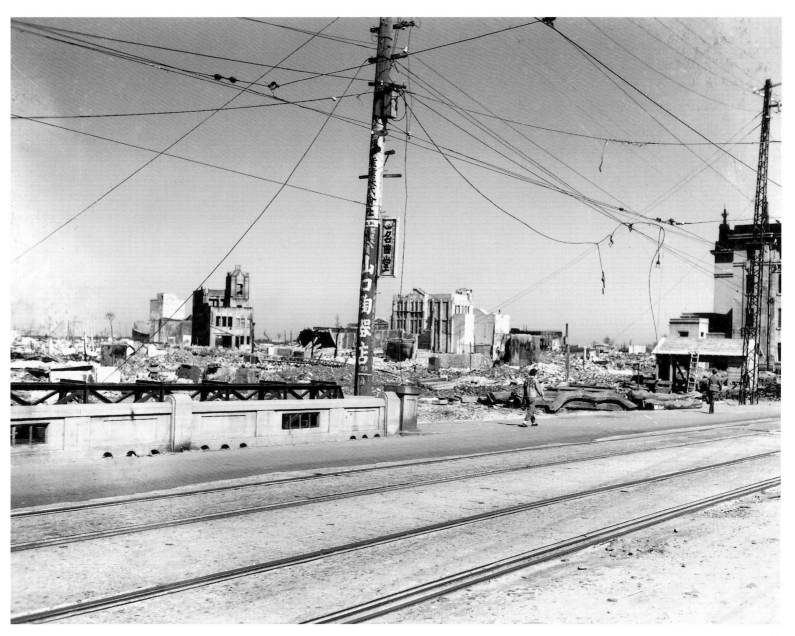

Nagasaki, Ground View

Grateful to have Boy, who could navigate all the rubble seen here, I traveled through Ground Zero.

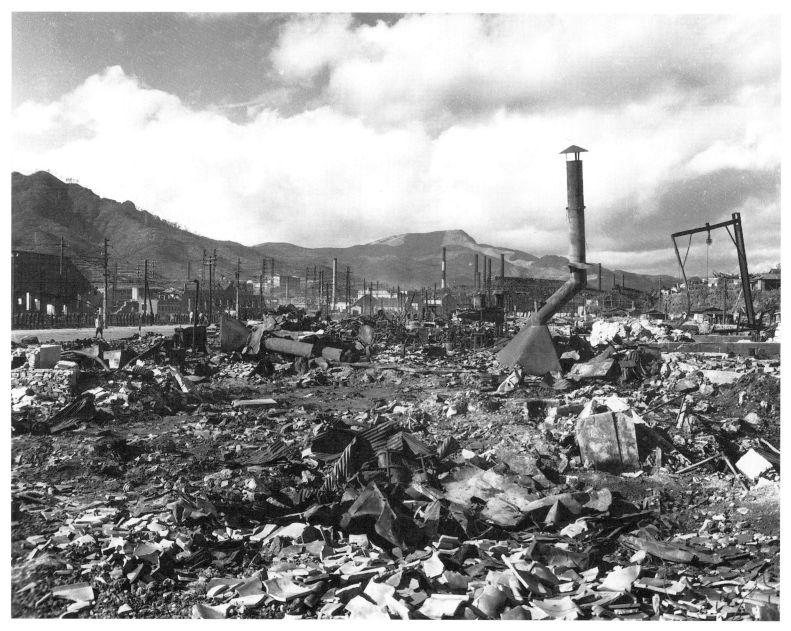

Mitsubishi Steel Works, Nagasaki

This mass of twisted steel was all that remained of the Mitsubishi Steel Works. The tall black-and-white towers could be seen clearly from the air, and were used by U.S. pilots as landmarks.

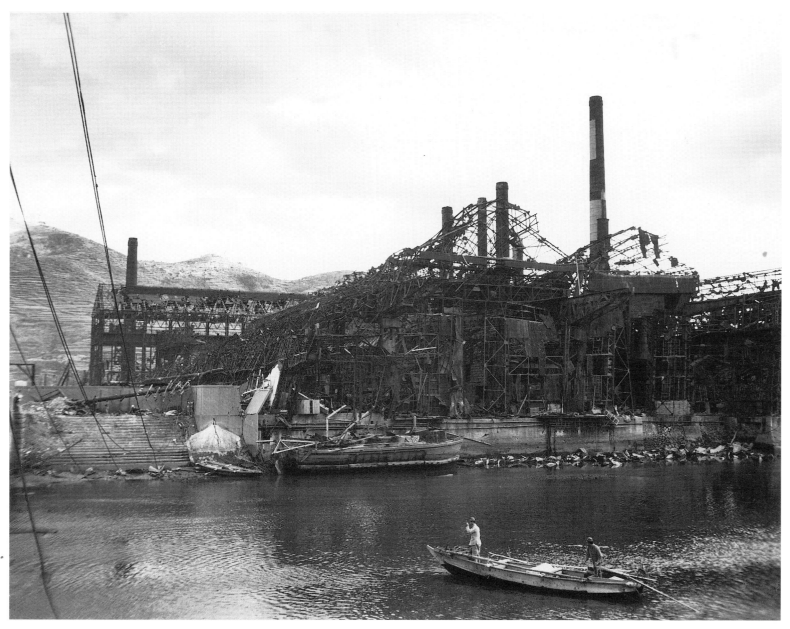

Panorama of Ground Zero, Nagasaki

The devastation from the second atomic bomb was so vast that I took two pictures and put them together to form this panorama.

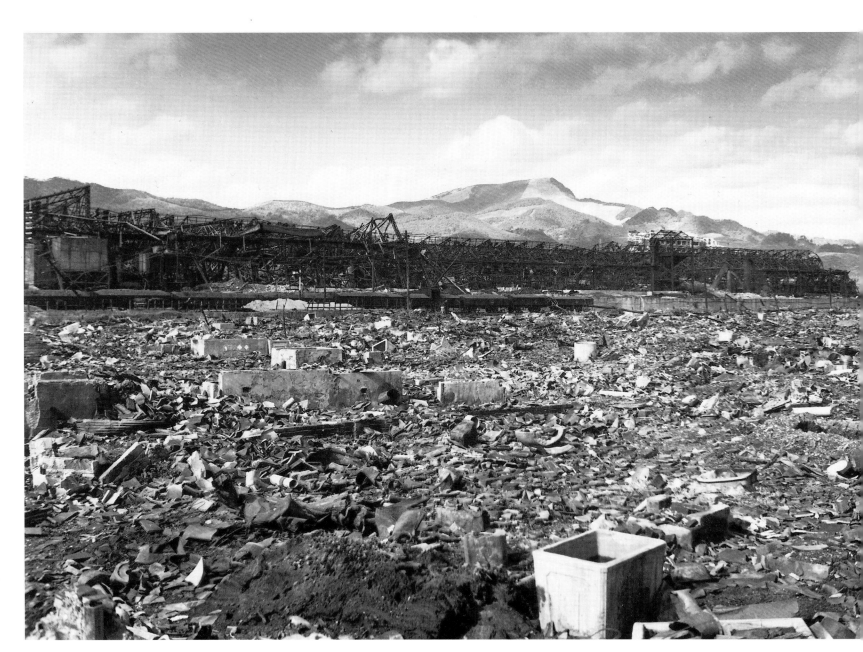

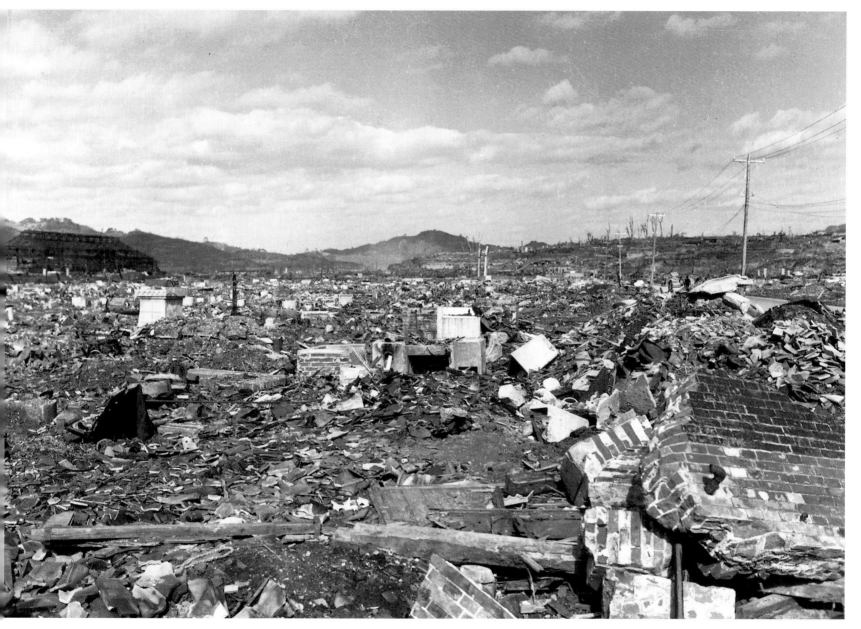

Prison, Nagasaki

While walking through the rubble close to Ground Zero, I noticed a long, high concrete wall. I entered through a ruined portion and found many small rooms attached to one another in the layout of a prison. The roof was gone, as were any remains. I was later told that the prison had held Americans and Koreans as well as Japanese.

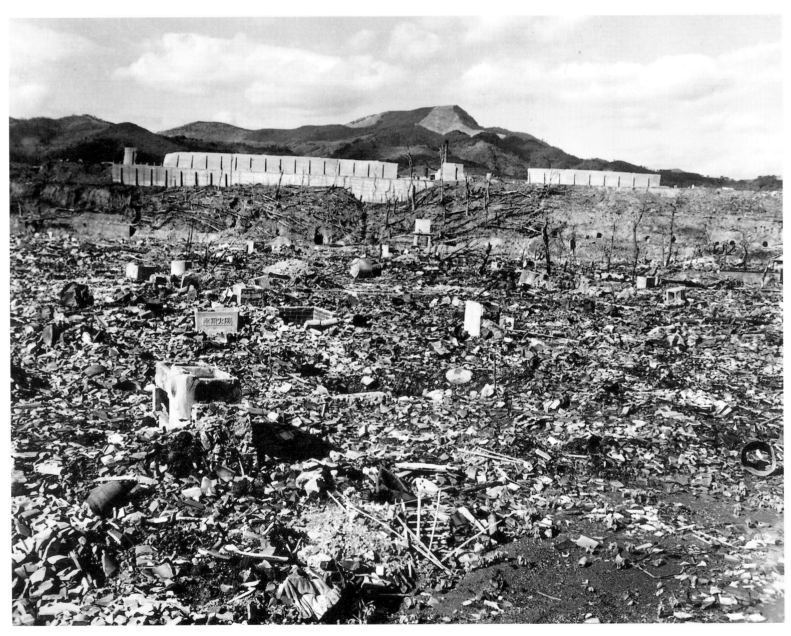

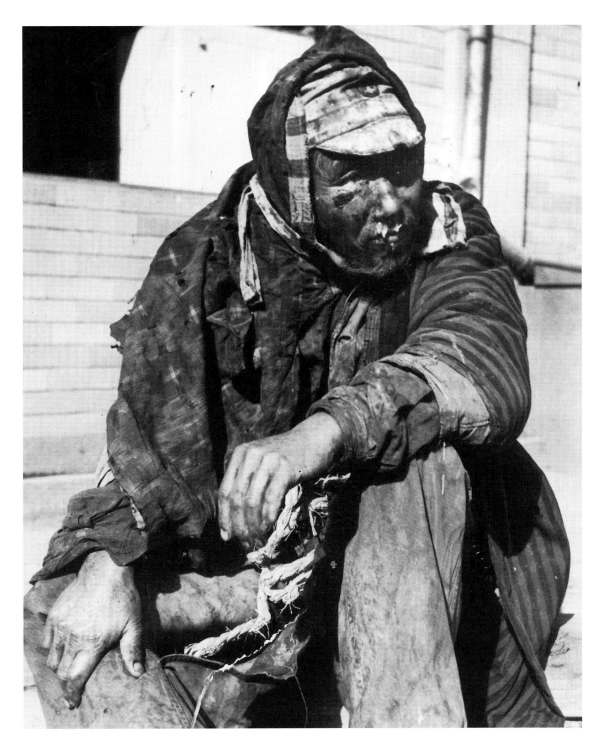

Victim with Rope

This man sat on the steps of a building that was turned into a hospital. He fingered a short piece of rope, his only possession. When I asked him why he wore so many clothes, he opened his coat to show me his burned, rotting flesh. He had layered his clothes to protect his wounds from the sun. Appalled by his condition, I asked the medical people inside what could be done for him. They told me they had already done everything they could by treating him with mercurochrome, a mild antiseptic, and the standard home remedy for burns, cucumber slices. In the immediate aftermath of the bombing, these were the only medicines available.

Burn Victim

Workers rolled this boy of fourteen onto his side to encourage drainage from his terrible burns. I was almost glad he lay in a coma, considering the excruciating pain the wounds must have caused. Flies and maggots feasted on his oozing sores. I waved the flies away with a handkerchief, then carefully brushed out the maggots, careful not to touch the boy's skin with my hand. The smell made me sick and my heart ached for his suffering, particularly because he was so young. I decided then that I would not take other pictures of burned victims unless ordered to do so.

He survived these terrible burns. I can't express my surprise and pleasure at meeting him again forty-eight years later on November 12, 1993, in Nagasaki.

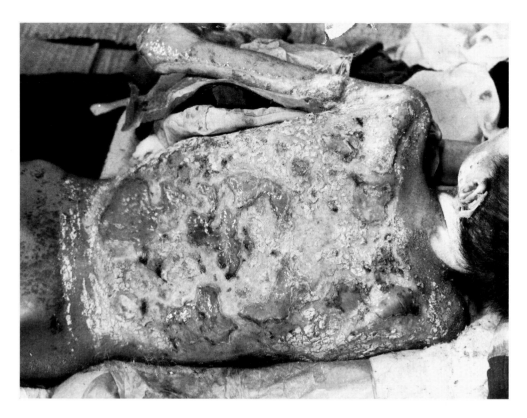

Skulls and Bottles

These skulls and various bones were carefully piled up by a Japanese clean-up crew in Nagasaki. The sake bottles were left for the spirits of the dead.

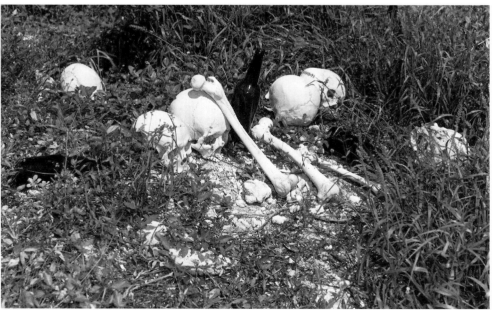

Three Brothers, Nagasaki

As I approached the outskirts of Ground Zero, I came upon these three children. The oldest child was pushing the younger ones in this makeshift cart. They stopped and looked at me, uncertain as to what I might do. I gave the oldest one an apple; he bit into it, then passed it to the next child. At once, a swarm of flies descended on the apple, but the children shared the apple in solemn silence, oblivious to the flies flying in and out of their mouths.

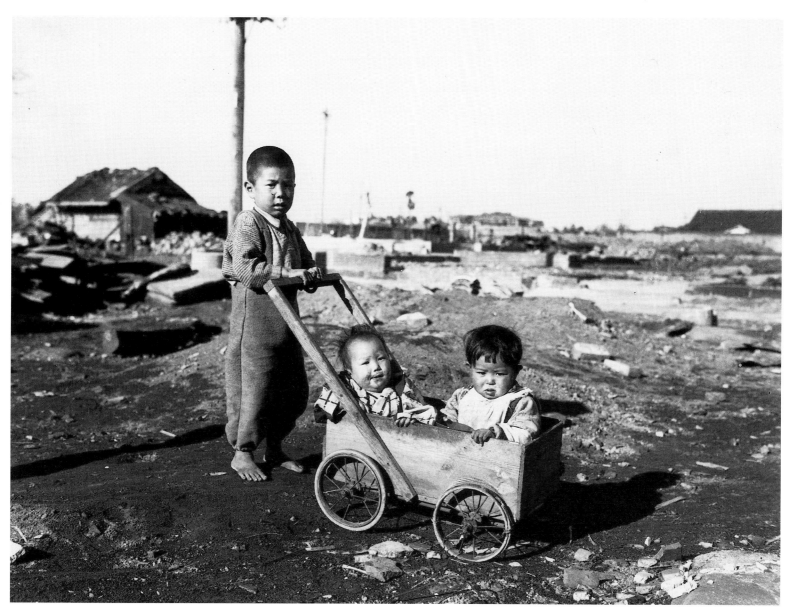

Dressed Up Little Girl

After offering this child and her mother candy, I asked why the little girl was so dressed up. Through signs and a few English words, the mother explained that it was a special day and they were going to the shrine. She also told me that the child couldn't hear. When American bombers were sighted, mothers would run to their children to stuff cotton or soft cloth into their ears to protect them from the sounds of the explosions. Unfortunately, this mother didn't get to her daughter in time.

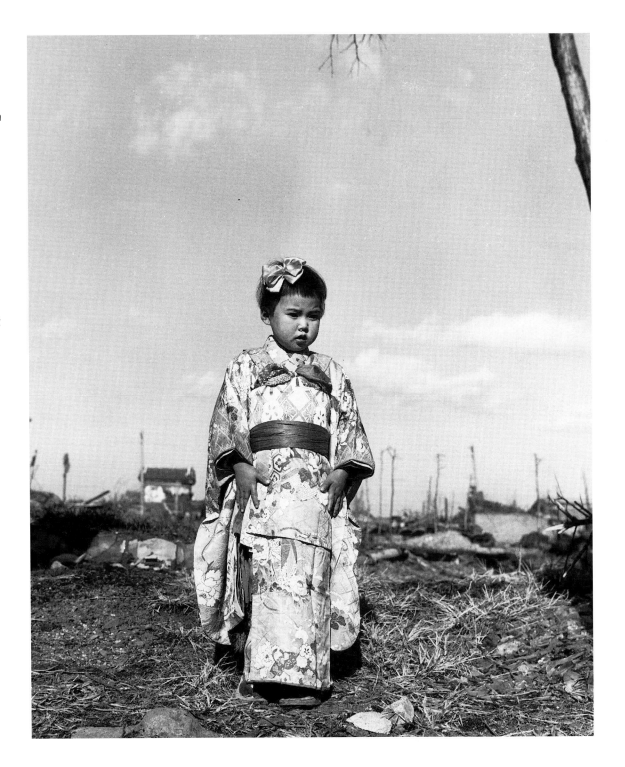

Classroom

Outside the window was a grim scene of what had once been a playground. Not one child even glanced at me, all keeping their complete attention on the instructor, who also ignored me and simply continued his lecture. Feeling very out of place, I quickly took my photographs and left.

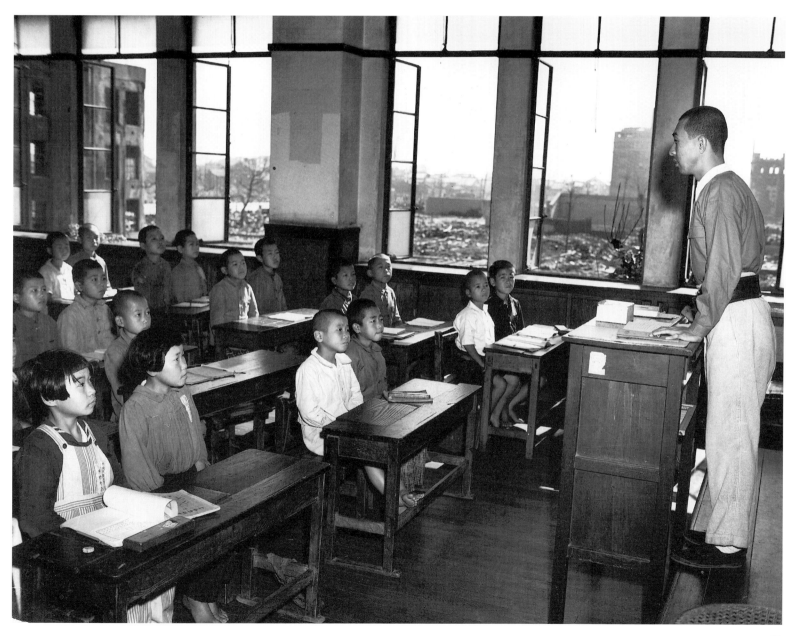

Cremation Site, Nagasaki

I had never before witnessed the obvious military influence on the young until I watched this boy bring his dead brother to a cremation site. He stood at attention, only the biting of his lower lip betraying his emotions. I wanted to go to him to comfort him, but I was afraid that if I did so, his strength would crumble.

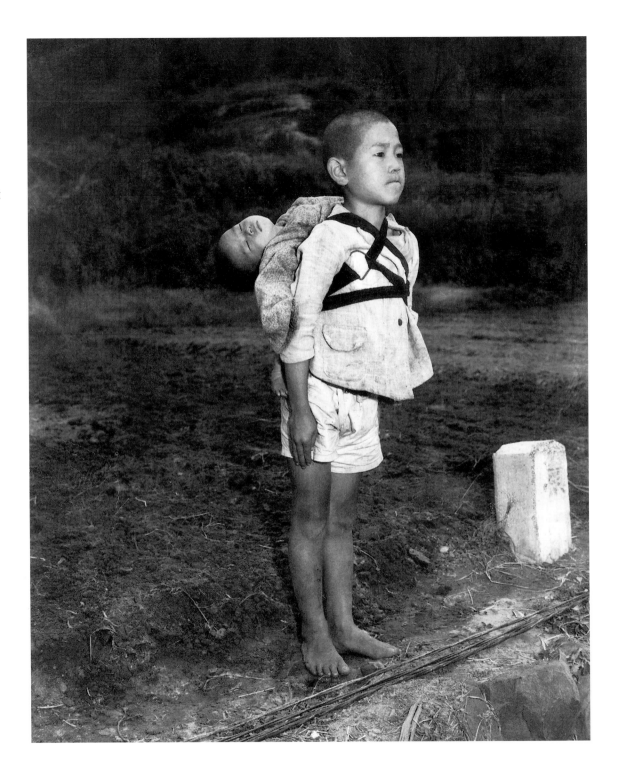

Trees
These trees caught my attention as I walked by on my way to the prison, seen on the right. I prayed that this would be the last atomic wilderness.

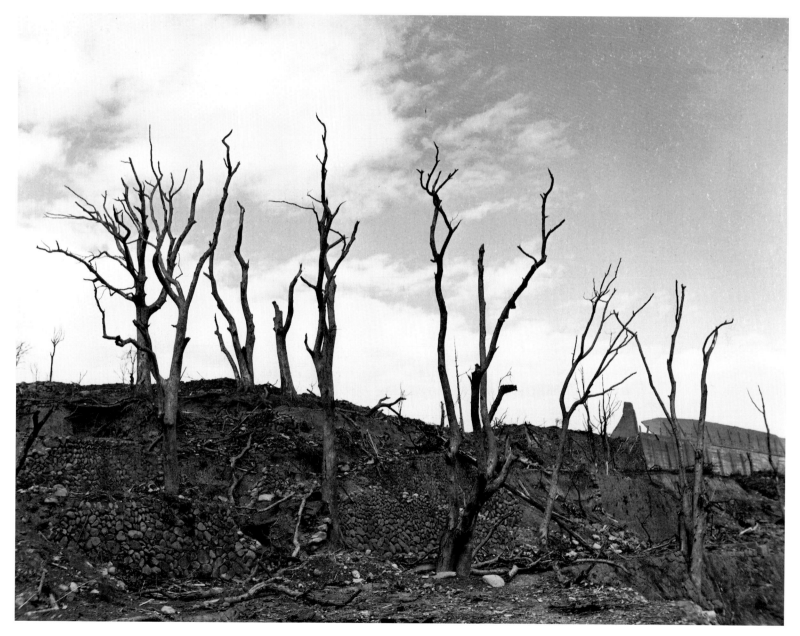

Clock Tower

As I flew over Nagasaki, the clock tower in this church caught my eye. I asked the pilot to make a low altitude pass. The clock's hands were frozen at 11:02, the moment of the atomic bomb's detonation. Noticing that the windows of the church appeared intact, I asked the pilot to land on the street in the upper left of this photograph.

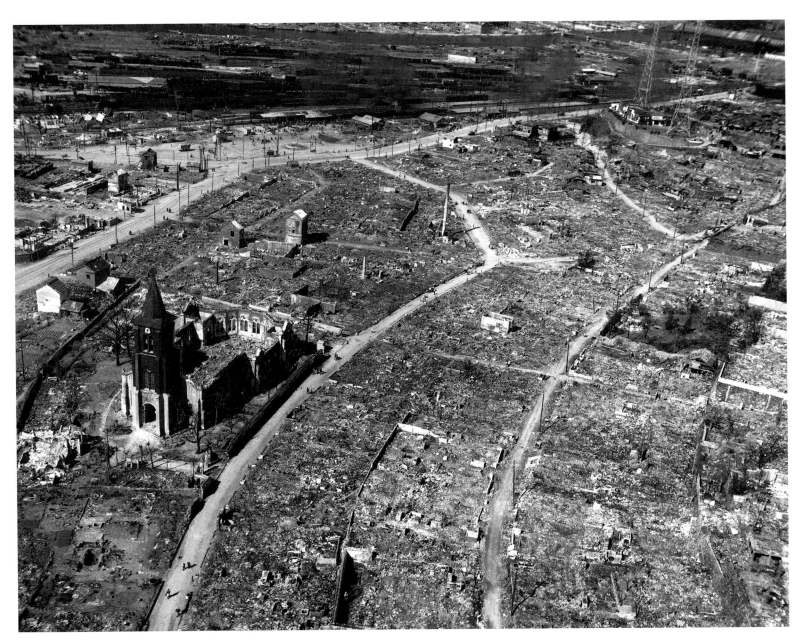

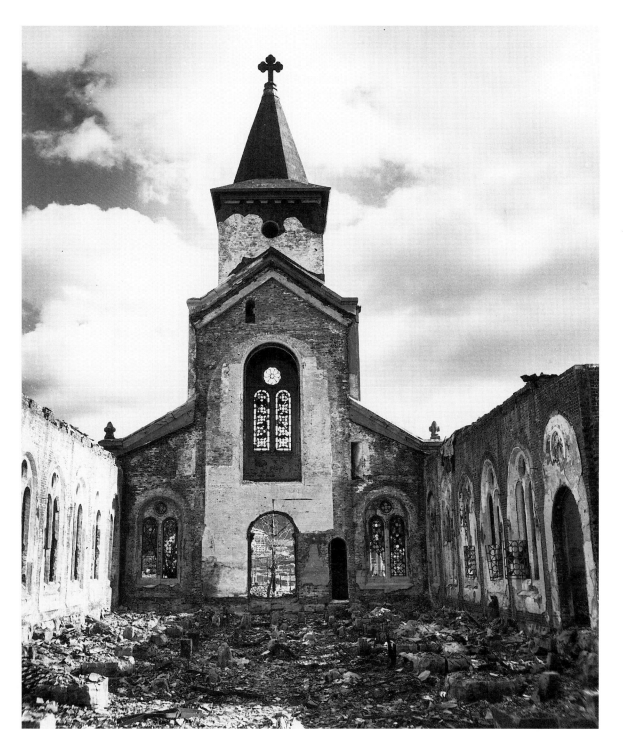

Stained Glass

I trudged through the debris towards the ruins and took this photograph.

Nuclear Rubble

1800 feet above this exact spot was the hypocenter, where the nuclear bomb exploded. Upwards of 80,000 humans vanished in the blink of an eye, with 140,000 dead by the end of the year. The extraordinary temperatures caused brains to boil and skulls to explode, making remains very hard to identify. I showed this photograph to my orthopedic surgeon. To my surprise, he was not only able to identify the bones of an adult, but stated that there were remains of at least three people, one a child.

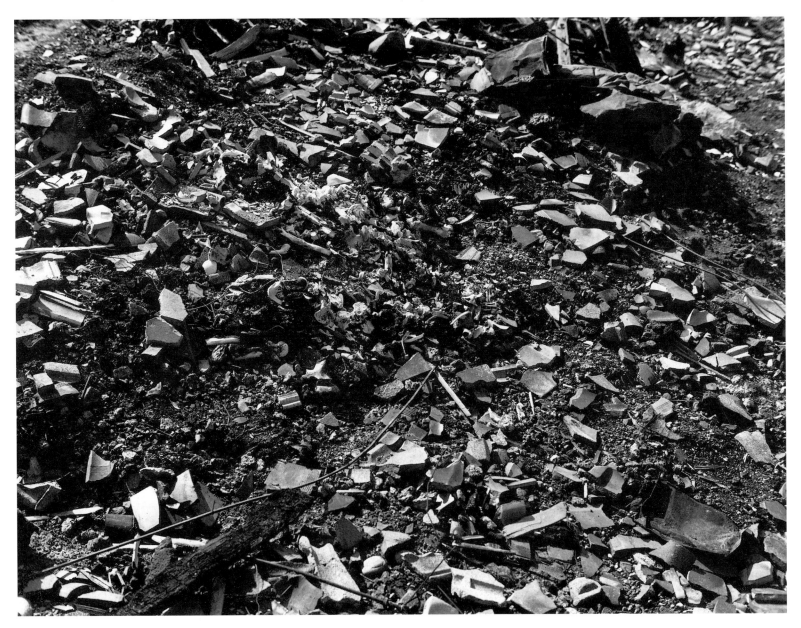

"Calvary" in Nagasaki

The starkness of the black outline of Urakami Cathedral on the hillside against the setting sun reminded me of the hill on which Jesus was crucified.

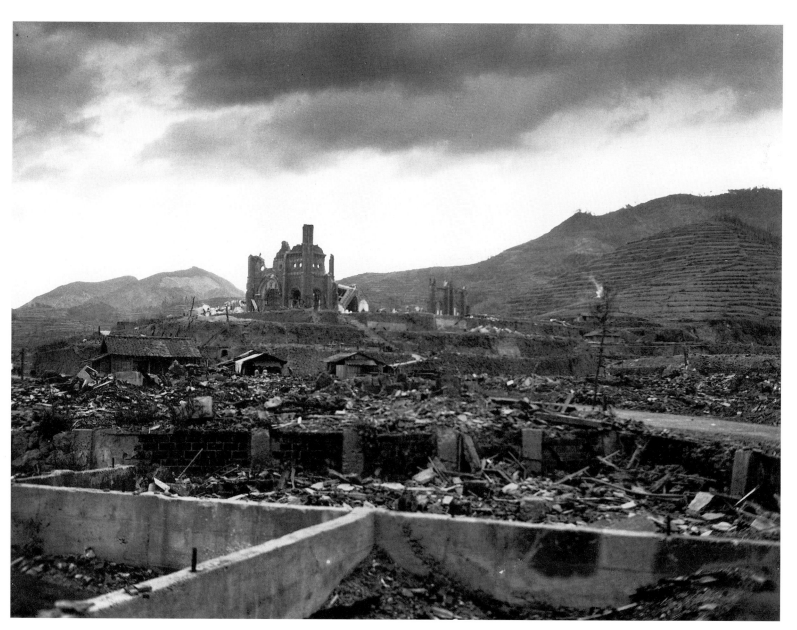

Urakami Cathedral
The dome of the cathedral, like the head of a sleeping giant, rests on its side in the ruins.

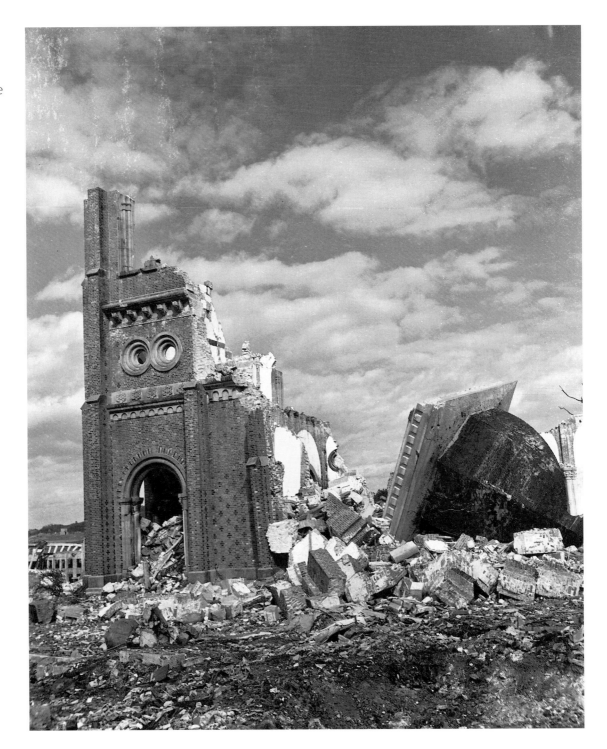

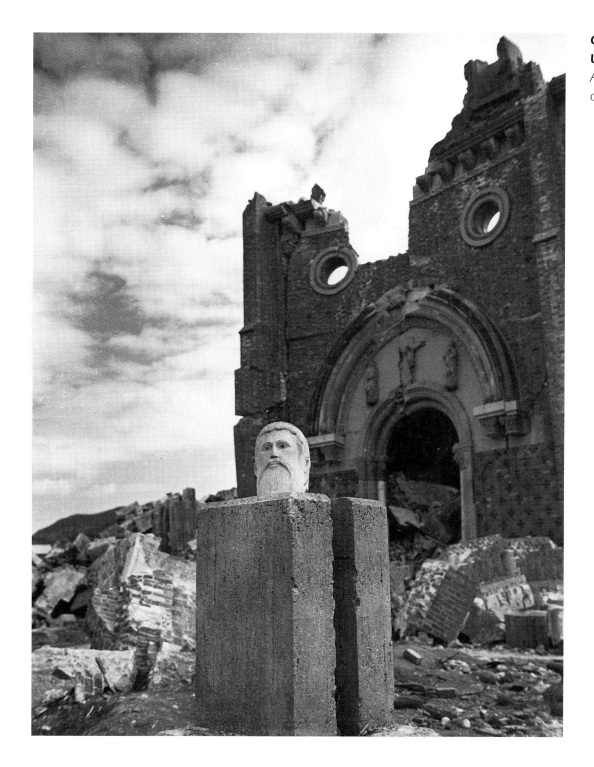

Concrete Head, Urakami Cathedral
A silent witness stares out over Ground Zero.

Annotating Negative Sleeves

After taking photographs in Japan, I made notes on the back of negative sleeves to remind myself about the circumstances.

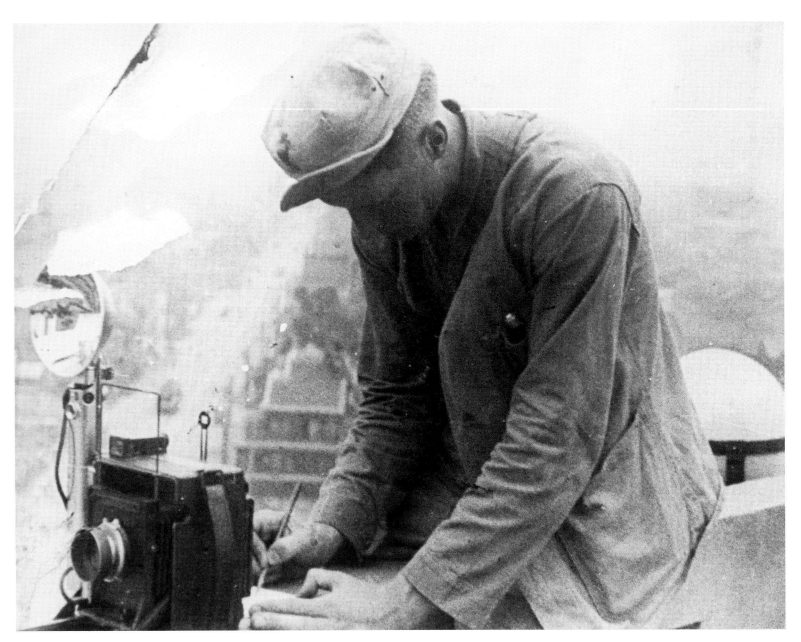

Afterword

The corner store was owned by Tony Aveni. It was located right across the street from the inclined plane at the corner of Union and Vine Streets in Johnstown, Pennsylvania. Mr. Aveni had the patience of Job, putting up with four of us teenagers all the years we were growing up. We hung out at the store evenings and weekends.

One day in 1936, after the Johnstown flood, President Roosevelt drove by as he toured our stricken city. Mr. Aveni called out, "Mr. President, the water was up to there," pointing to the water mark twenty-two feet up on the front of the corner store. I took a picture of the President as he drove by in a convertible, his hat turned up and a cigarette holder holding a cigarette at the end. I used an early Kodak box camera, the smallest I have ever seen, one that took 35 mm film.

Mr. Aveni had a son Joe, about my age, who ran the store much of the time, which made it nice for us guys. Years later, for his nineteenth birthday, Joe received a tiny electric portable radio. One day he brought it into the store. Joe stood on one side of the candy counter with the three of us on the other side. He turned on the radio to some music that none of us cared for. Then he changed it to another station with a football game, and we all came to life. "Who's playing? What's the score? Turn it up, Joe, we can't hear!" He yelled back at us, "I'm not going to turn it up, the radio will burn out." I reached over the counter and turned up the volume anyway.

The radio went silent. Joe had a fit, screaming, "I told you guys!" It seemed like forever, but after a few seconds of silence the announcer broke in. "The President of the United States has just announced that the Empire of Japan has attacked Pearl Harbor by land, sea, and air." Ken Reese was the first to speak, "Where is Pearl Harbor anyway?"

Little did we know that we all would go through Pearl in the months ahead en route to the South Pacific. It would be the last time we would ever see each other. The war lasted almost four years until the atomic bombing of Hiroshima and Nagasaki.

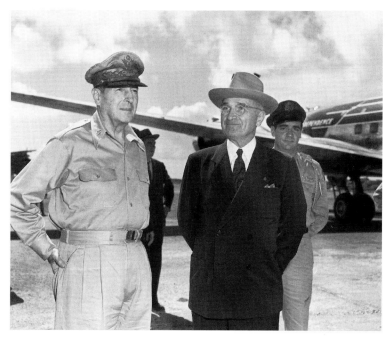

General MacArthur and President Truman met on Wake Island in October 1950.

After the war, I couldn't wait to return to the memories of my childhood that I had longed for while in the service. One of the first things I did was go back to Johnstown and walk down to the corner store. It was gone. I learned that after Mr. Aveni died the store had been torn down. I couldn't go back to the comfortable innocence of my youth.

Like Mr. Aveni, I had occasion to speak to Presidents, because after the war, I became a White House photographer.

I had always wanted to ask President Truman about his decision to drop the atomic bomb on Japan. As a White House photographer, I had many opportunities. I was with him often in the Oval Of-

fice, on his walks around Washington and through Georgetown, at Press conferences and bill signings, and meetings with dignitaries.

But I always held back; I did not want to seem too forward. Plus, we rarely talked to the President unless he spoke to us. Then one day the opportunity came. It happened, ironically, halfway around the globe, during Mr. Truman's visit to Wake Island in the North Pacific to meet with General Douglas MacArthur in October 1950.

After lunch, the President asked a few of us if we wanted to walk along the beach with him. We walked briskly for a mile or two, then the President stopped and said in that famous, earthy way of his, "I don't know about you fellows, but I've got to piss!" On the walk back, I was beside the President and the thought occurred to me that never would I have a more opportune moment to ask my question.

"Mr. President," I said, "I was a Marine photographer assigned to Hiroshima and Nagasaki after the war, and I often wondered if you had any second thoughts about your decision to drop the bomb on those cities." His reply startled me. It was quick and loud, if somewhat cryptic.

"Hell, yes! I've had a lot of misgivings about it, and I inherited a lot more, too!"

I had no idea how to reply, and the moment passed. But I'm glad I asked the question—and glad to know that Harry Truman was human, too.

When I opened the trunk in 1989, I pulled out pictures like this one of one of the boys who followed me around as I toured Japan after the atomic blasts. The baby on his back was badly burned, as you can see from the scabs on his head. Many of these children lost both parents to the war or to the atomic bombs. Some were fortunate enough to find places with relatives, but many others had no living relatives and had to become both mother and father to the babies. I don't know where they slept, what they ate, or even

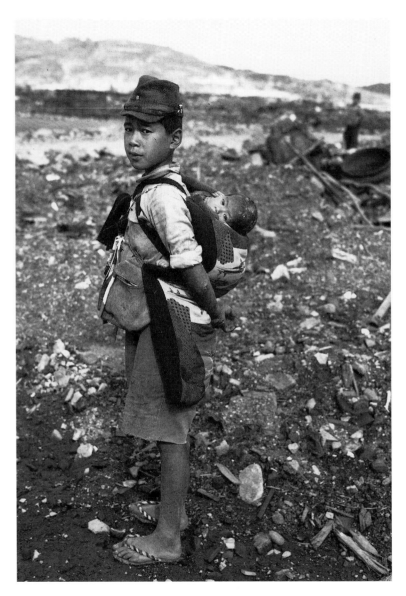

This is a picture of one of the boys who followed me around in Japan. The boy and the baby were orphans.

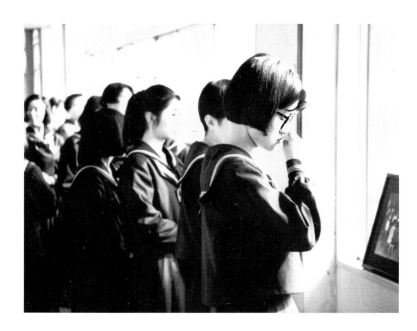

if they survived. It is estimated that there were over 6500 A-bomb orphans in Hiroshima alone.

From the photos in the trunk, I created a small exhibit in Nashville. Later the photos were exhibited elsewhere in museums, churches, and universities in the United States, in cities like Hamburg, Vienna, and Berlin in Europe, and most important in Japan. As Richard Lammers recalls:

When we first met Joe and his pictures at Brookemeade [Congregational Church in Nashville] in 1991, we had with us a group of Japanese we were leading to visit churches and various institutions while staying in American homes. Among the group was the Director of the Good Neighbor Christian Center in Morioka, where my wife and I had worked for about 21 years. He was deeply impressed with Joe's pictures and insisted "we must work out arrangements for Joe to show those pictures in Japan. We've not seen pictures like that of what really happened in Hiroshima and Nagasaki." So, by the next year in 1992 we were able to arrange for the pictures to be shown first at the Good Neighbor Christian Center from October 13 to 18, 1992. There was a wonderful turnout for the pictures.

Joe's panoramic picture of the destruction in Nagasaki—it must have been something like 12 feet by 6 feet—was placed at the front of the display hall. It was very impressive. Many people stood for quite a few minutes to meditate on what the picture was all about. One young man stood there for a while and I approached him to talk about what he was thinking and I soon knew why he was so deeply moved with the sight when he said: "My home was just over the hill there on the left side of the picture." Then he went on to explain how he had seen the flash of light when the bomb exploded and how quickly everything in his viewing area had become a wasteland, with buildings destroyed, and thousands of his fellow citizens dead.

Another person told how he was helping to clean up the school of which the walls were still partly standing. Near enough to the epicenter to get the full affects of the radiation. Students, some still seated by their desks, dead. A dreadful sight.

Another conversation was with a man who had been in Hiroshima with a group of 285 soldiers. He and one other soldier were the only survivors from this group. So the task of taking care of the dead was part of his responsibility. He told how the river, near what is now the Peace Park, became so filled with dead bodies of people who had tried to escape the great heat that the river overflowed. There was no way of identifying the bodies. The stench of dead and rotting flesh was unbearable. Nothing could be done but to set off some dynamite to blow up the bridge holding back the bodies so that the bodies could float off down the river to the ocean. Another man spoke of walking across the river over the dead bodies.

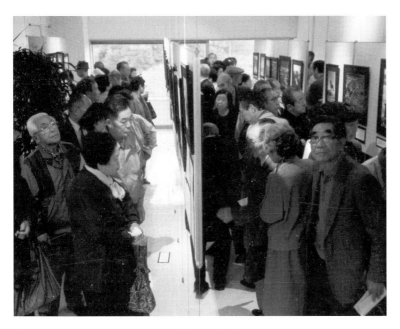 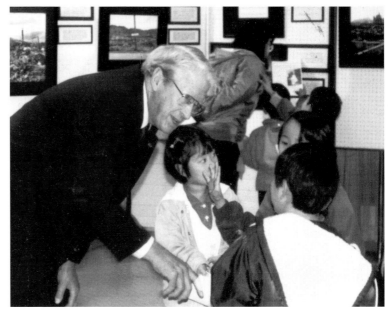

Snapshots from the Japanese exhibits and talks.

But for all that these people had experienced I can say that no one—and I emphasize no one—spoke to us angrily or pointed an accusing finger at us. They also seemed to understand that Joe was not there to accuse the Japanese for what they did. We were simply strengthening one another's personal convictions that what we were remembering through these pictures must not happen again. Our conversations would almost always end with "This must not ever happen again!"

From Morioka we went to Aomori, Hirosaki, Akita, and Shinjo in the three northern prefectures of Honshu. Christian churches, or churches together with community groups and/or the prefectural offices, were in charge of the arrangements—a place to display the pictures and the publicity. In Aomori the church full of people (about 120) heard Joe tell his story. That afternoon he said: "Don't

tell Morioka, but being here in Aomori has been even better." And so it continued: every exhibit with new surprises and blessings. The reason this trip was so valuable was that this was Joe's story, a story that no one else could tell and that's what gets to people. It was there that Joe realized as never before that he as one person has a very special mission. A very special mission that I believe continues until the present day and hopefully can be accomplished again through this new book.

After Aomori, too, in every place we visited, we felt that Joe's mission was a real healing ministry. After our Honshu exhibits had ended, we went to Hokkaido to the city of Sapporo, November 6–8. In Sapporo we learned that there was a local group in the process of developing a mini-museum where they could display materials that would highlight the Hiroshima-Nagasaki tragedies

and pay tribute to those who had lost their lives as well as the "hibakusha," those still living but who continued to suffer from the effects of radiation. After Hokkaido we were on our way home again stopping on our way in Morioka and then before leaving Tokyo for one more presentation at the Aoyama Girls School in Tokyo. Our return flight was November 15.

Wherever we went the media, local and national newspaper reporters, local and national television reporters, were there to take pictures and ask questions. Our exhibit thus became known throughout Japan. At each location arrangements were made to have a time when the public was invited to hear Joe tell his story.

Somewhere in the archives there may be pictures of Hiroshima and Nagasaki at the time of the bombing, but when we took these pictures to places in more rural areas, pictures had not been

released for the general public to see. Therefore, Joe's pictures had a special impact on those who came to see them. Joe's captions to the pictures seemed to convey a sense of compassion for those who died such a violent and quick death as well as a concern for those who continue to suffer from the radiation effects all these years later, of which Joe himself was an example.

On subsequent trips Joe was able to meet other survivors. I have the Japanese Yomiuri English Newspaper clipping showing the picture Joe took in 1945 of a boy whose body was covered with burns (page 70) along with an account of Joe shaking hands forty-eight years later with the man who survived those burns.